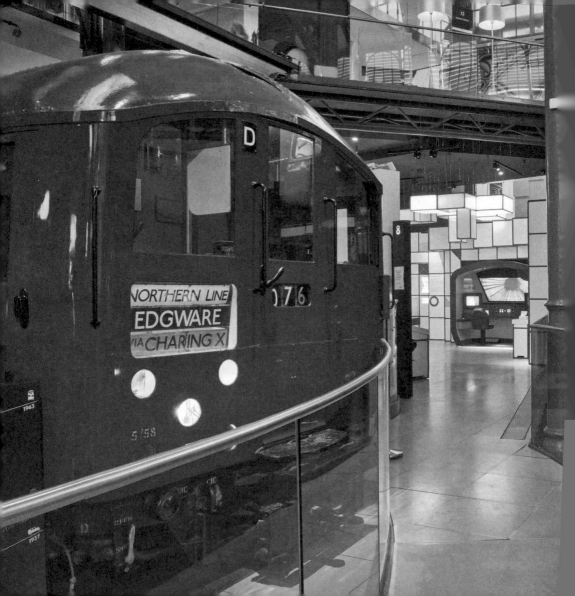

LONDON'S MUSEUMS AND GALLERIES

EXPLORING THE BEST OF THE CITY'S ART AND CULTURE

ELEANOR ROSS

FRANCES
LINCOLN

CONTENTS

INTRODUCTION

Artworks and artefacts have been inventoried, curated, collected and displayed in London for hundreds of years. Victorian explorers returned from the Far East with all manner of exotic treasures. More recently, the city has been home to immigrants whose diverse cultural heritage has contributed to striking art trends. Both phenomena find expression in the numerous museum collections and gallery spaces across the metropolis today.

London is home to one of the world's oldest collections, the Royal Armouries at the Tower of London. It opened to the public in 1660, when people flocked to see the fine suits of armour and weaponry on display. Britain's first purpose-built, public art space, Dulwich Picture Gallery, opened in South-east London in 1817. Big-name spaces such as the Tate, the Imperial War Museum and the National Gallery remain perennial favourites.

Families are well catered for. Many venues have special features for kids - colouring in, dressing up and spotting objects within exhibits among them. Favourites include the Science Museum, the Natural History Museum and the Museum of London (opposite), but they will also enjoy seeing Quentin Blake's illustrations for Roald Dahl's *Matilda* at the House of Illustration, or taking a ride on the underground railway at The Postal Museum. And there are countless other quirky spaces to happen on, from Second World War battleship HMS *Belfast* to the Estorick Collection of Modern Art, home to one of the world's finest collections of twentieth-century Italian art.

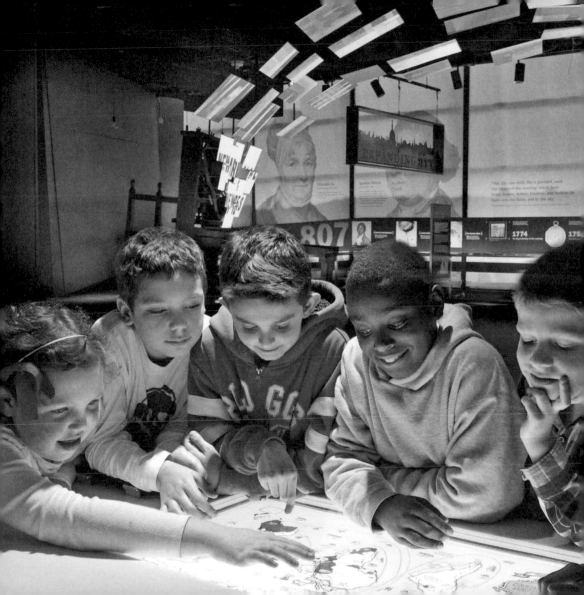

TICKETS AND PASSES

The vast majority of London's museums and galleries have free entry because they're subsidised. However, you may find yourself paying extra for rotating exhibitions. Tickets can be quite pricey - often upwards of £15 for a temporary show. Bear in mind, also, that popular shows get booked up quickly. For big 'blockbuster' exhibitions, it is always advisable to book in advance to avoid ending up with a poor time slot. This is especially the case if you plan to visit on a Saturday. There are, of course, ways to save money on exhibitions. Many venues offer concessions, and even free entry, for children, full-time students and pensioners. Anyone in receipt of Universal Credit, Pension Credit, Income Support or a Jobseeker's Allowance can also request a reduced ticket price with proof of such. Disabled people often gain reduced entry, as do their carers.

National Art Pass

With a National Art Pass, you qualify for reduced rates or free access to 240 galleries across the United Kingdom. Many of the museums in this book are either free or offer a fifty per cent discount on entry, and include major exhibitions. The pass costs £70 a year. Members receive a subscription to *Art Quarterly* magazine and a map of all participating venues.

London Pass

The London Pass costs £75 a day for adults, and covers some of London's biggest-hitting attractions, such as the Shard, the Tower of London and Westminster Abbey. The pass is good value if you also plan to see several tourist attractions in one day, but is not ideal for exploring museums and galleries only, since most of them are free.

LONDON LATES

There are two categories of 'lates': venues that stay open late one day a week or once a month; and venues that open late for specific events or talks. Events that occur in the latter category are normally ticketed. They are particularly worth seeking out at the Natural History Museum, the Royal Academy of Arts, the Sir John Soane's Museum and the Victoria and Albert Museum, where you can expect talks, cocktails, games, workshops, and more. Listed below are the regular lates for venues in this book. Times and prices are subject to change, so check websites for details.

Wednesday: Ben Uri Gallery and Museum, City of London Police Museum, Science Museum (last Wednesday of the month), South London Gallery

Thursday: Cartoon Museum, Fashion and Textile Museum, Goldsmiths Centre for Contemporary Art, Hayward Gallery, The Photographers' Gallery, Saatchi Gallery, Wellcome Collection, Whitechapel Gallery

Friday: British Museum, National Gallery, National Portrait Gallery, Natural History Museum (last Friday of the month) Royal Academy of Arts, Saatchi Gallery, Tate Britain, Tate Modern

Saturday: Saatchi Gallery, Tate Britain, Tate Modern

PRICES

Most venues are free entry. For those that aren't, check websites for details. Ballpark figures are given in our listings, as follows:

£: £5-10 ££: £11-15 £££: £16-20 ££££: £21+

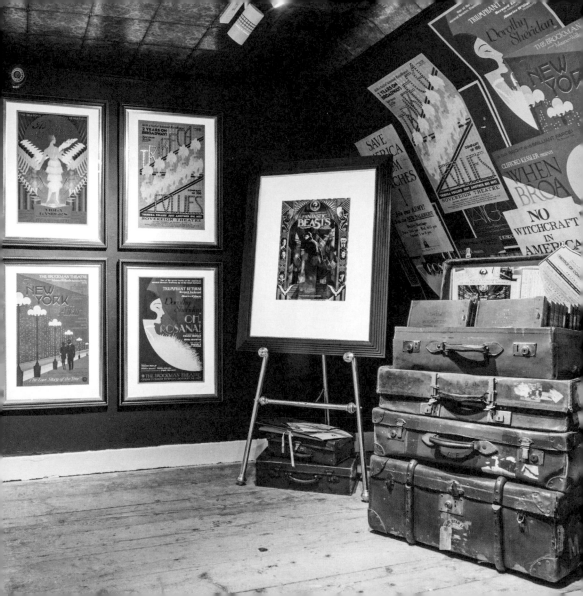

CENTRAL LONDON

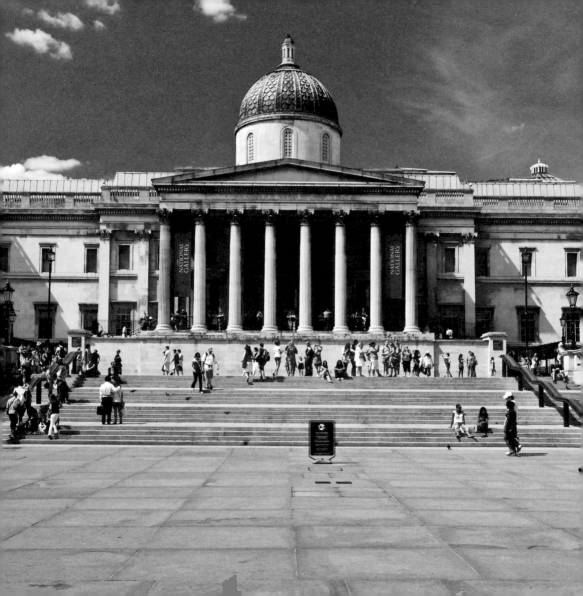

CENTRAL LONDON

With its red buses, famous landmarks and verdant parks,
Central London feels like a museum in itself. It is crammed with
some of the world's best exhibition spaces, so visitors and locals are spoilt
for choice. After all, where else can you find works by Vincent van Gogh
sitting just 400m (1,300ft) away from an ancient Egyptian sarcophagus?
If you want to see London's big-hitters, stay central. Institutions such as
the National Gallery (opposite) and the British Museum are so vast and
sprawling that you'd need to visit countless times to do them justice, but most
of London's big buildings have handy checklists for visitors with less time on
their hands. Other special museums include the Wellcome Museum, across
the road from Euston Station – a great place to learn about health – and
Soho's House of MinaLima, where you can explore the artistry and illustration
behind the Harry Potter films. Indulge in the fine arts at the Royal Academy,
but also take the time to check out some of the lesser-known museums
dedicated to magic, toys, dentistry, cartoons, and more.

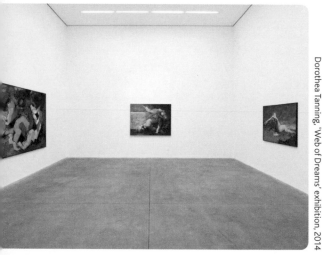

Dorothea Tanning, 'Web of Dreams' exhibition, 2014

✛ ALISON JACQUES GALLERY
MODERN/CONTEMPORARY ART

The entrance to Alison Jacques Gallery is modelled on New York Chelsea gallery facades, with thick sheet glass set into a flat, white frontage. Inside, the ceilings are over 5m (16.5ft) high above stark white walls. Alison Jacques is known as a pioneer of overlooked or unacknowledged artists, such as Maria Bartuszová, Irma Blank, Lygia Clark, Roy Oxlade, Dorothea Tanning and Hannah Wilke. Photographers include Juergen Teller and Gordon Parks, with Jacques representing the estate of the iconic American artist Robert Mapplethorpe since 1999. The gallery roster includes major players on the international contemporary art scene, including Sheila Hicks, Takuro Kuwata, Ian Kiaer, Graham Little and Erika Verzutti.

—

16–18 Berners Street, W1T 3LN
020 7631 4720
www.alisonjacquesgallery.com
Tues.–Sat. 11:00–18:00; free
Tottenham Court Road Tube

✤ BRITISH DENTAL MUSEUM

<u>HEALTH AND MEDICINE</u>

Teeth don't immediately spring to mind as something you want to spend time looking at, but this is a fascinating little museum. It was founded in 1919 when Britain's first female dentist donated paraphernalia and tools to the cause. The collection's 2,000 objects date from the seventeenth century to the present day, and include anatomical models that students used to practise on and vintage pieces of dental equipment, as well as a range of today's more sophisticated drills and gadgets. There's also a fine collection of objects relating to dental care at home. Among the stranger curiosities on display is a sculpture made from crab shells of a woman visiting the dentist. Don't miss the agonisingly painful-looking pictures of nineteenth-century dentists tugging on teeth.

——

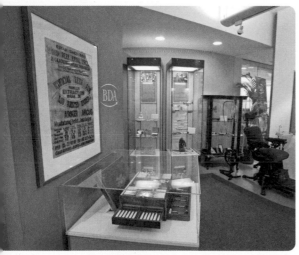

64 Wimpole Street, W1G 8YS
020 7563 4549
www.bda.org/museum
Tues. & Thurs. 13:00–16:00; free
Oxford Circus Tube

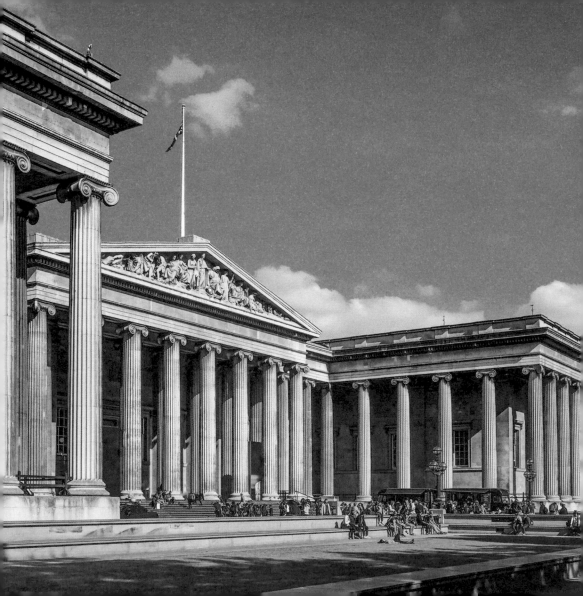

✤ BRITISH MUSEUM

CULTURAL HISTORY

This ancient and illustrious institution is crammed with curiosities, from Egyptian mummies to an entire gallery packed with ornate silver clocks. Occasionally you'll walk through a different entrance to the museum and happen upon something completely unexpected – a full-size reproduction of a traditional Korean house, for example. Besides the galleries packed with fragments from ancient worlds, the British Museum is architecturally stunning, particularly the Great Court, with its sculptural glass roof. This is the world's first public national museum, and operates as a meeting place as well as a massive display cabinet. The Rosetta Stone – the key to deciphering hieroglyphics – the Mummy of Katebet and the intricate Lewis Chessmen are among the many highlights of our shared human history. Admission is free, but expect fees for one-off exhibitions.

—

Great Russell Street, WC1B 3DG
020 7323 8000
www.britishmuseum.org
Daily 10:00–17:00 (Fri. 10:00–20:30); free
Goodge Street Tube

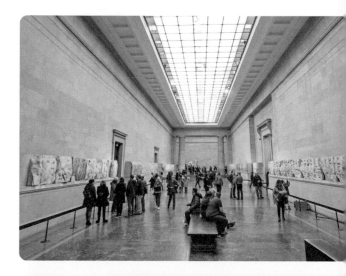

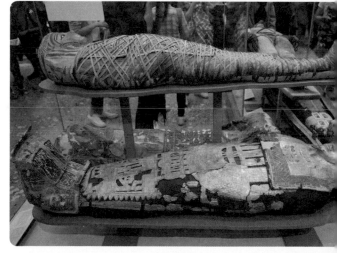

❖ CARTOON MUSEUM

GRAPHIC DESIGN

Packed into the basement of a stylish Fitzrovia townhouse, and with more than 8,000 prints and illustrations in its collection, this colourful museum considers Britain's contribution to the vibrant world of comics and cartoons. The bright rooms feature cartoons from as early as 1750, when they were used as a vehicle for satire and poking fun at the establishment, to the present day. A collection of *Private Eye* covers allows visitors to see how cartoons are still used to mock and belittle those in charge. The focus is less on comic books (although exhibitions pop up now and then) and more on the political cartoon. Among the highlights are a collection of Hogarth's reflections on society, original *Rupert Bear* strips and a series of posters from the Second World War. There's also an immersive, 3D cartoon – primarily a peaceful space with walls packed with pictures and prints.

63 Wells Street, W1A 3AE
020 7580 8155
www.cartoonmuseum.org
Tues.–Sat. 10:30–17:30 (Thurs. 10.30–20:00),
Sun. 12:00–16:00; £ (under 18s free)
Oxford Circus Tube

✤ CHURCHILL WAR ROOMS

MILITARY HISTORY

During the Second World War, an army of people operated twenty-four hours a day in the rooms of a bunker that winds its way beneath the streets of Westminster. This is where Winston Churchill made some of his most crucial decisions. See where he slept – he even delivered four speeches from his bed – and take a peek inside the telephone room disguised as a private toilet that Churchill used for secret calls to the US president. The map room, covered with details of Germany's advances and retreats across Europe, remains exactly as it was the day the lights were turned off in the bunker in 1945. As with other Imperial War Museum venues, the Churchill War Rooms are full of testimony, video and spoken eyewitness accounts, which makes a visit a moving and special experience.

—

Clive Steps, King Charles Street, SW1A 2AQ
www.iwm.org.uk
Daily 9:30–18:00; ££££
Westminster Tube

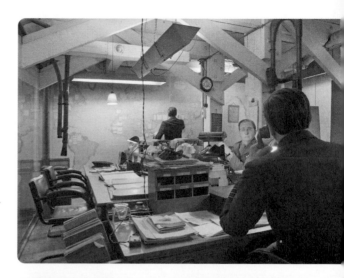

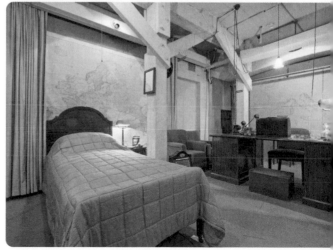

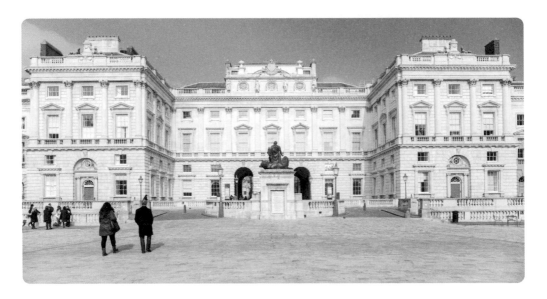

✤ THE COURTAULD INSTITUTE OF ART

FINE ART

Amedeo Modigliani's *Female Nude*'s head is tucked onto her shoulder. As you gaze at her portrait, it's almost as if you've disturbed her, crept up on her unawares. Located in the North Wing of Somerset House, just off the Strand, this gallery is splendidly peaceful. The Courtauld is the world's leading centre for the study of art history, conservation and curating. Its gallery is home to major works from the Renaissance through to the twentieth century, and includes an unrivalled collection of Impressionist and Post-Impressionist paintings by artists ranging from Manet, Monet and Renoir to Cézanne, Van Gogh and Modigliani. The Courtauld also hosts a number of major temporary exhibitions each year. The gallery has been closed since September 2018 in order to undertake a transformation project that will make its world-class artworks, research and teaching accessible to more people.

——

Somerset House, Strand, WC2R 0RN
0203 9477 777
www.courtauld.ac.uk
The Courtauld Gallery is closed at the time of writing. It is due to reopen later in 2021. See website for details; £££
Temple Tube

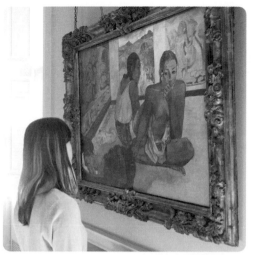

❖ DAVID ZWIRNER

<u>MODERN/CONTEMPORARY ART</u>

This Mayfair gallery displays some of the most interesting work outside of London's large, national galleries, with shows from big, blockbuster names such as Bridget Riley and established artists that include Josef Albers. David Zwirner first opened in New York's Soho twenty-five years ago. Today, the gallery network plays a vital role on the global art circuit. Zwirner focused in on lesser-known artists, especially at the start of his career – a gamble that appears to have paid off, since you can now expect to view works by some of today's most successful artists. Plan to spend an hour here, padding up the central wooden staircase and taking in the full visual effects of whatever artist happens to be on show. Past exhibitions have included Jockum Nordstrom's 'The Anchor Hits the Sand', while sculptural and installation artists such as Yayoi Kusama, Dan Flavin and Carol Bove have all been exhibited on the Zwirner network.

24 Grafton Street, W1S 4EZ
020 3538 3165
www.davidzwirner.com/galleries
Tues.–Sat. 10:00–18:00; free
Green Park Tube

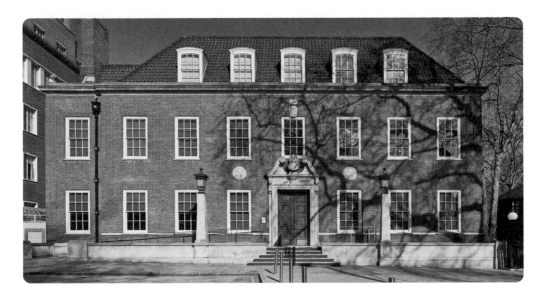

✤ THE FOUNDLING MUSEUM

SOCIAL HISTORY

The Foundling Museum was nobly founded by Thomas Coram in the eighteenth century, to take care of babies at risk of abandonment. With recruits William Hogarth and George Frideric Handel, Coram encouraged leading figures in society to donate and support the children. In 1739 he received a royal charter from George II to establish the hospital. From 1741 to 1954, the hospital cared for and helped re-home around 25,000 children. A number of influential artists donated artworks to the hospital, which has since become this museum. Exhibitions have included the portrayal of pregnancy in works from Hans Holbein to social media, while the permanent collection includes an original score of Handel's *Messiah* and paintings by Joshua Reynolds. Uniforms, crockery and other items taken from daily life at the hospital are also on display. Proceeds from events and ticket sales continue to support children in need.

—

40 Brunswick Square, WC1N 1AZ
020 7841 3600
www.foundlingmuseum.org.uk
Tues.–Sat. 10:00–17:00, Sun. 11:00–17:00; ££ (under 21s free)
Russell Square Tube

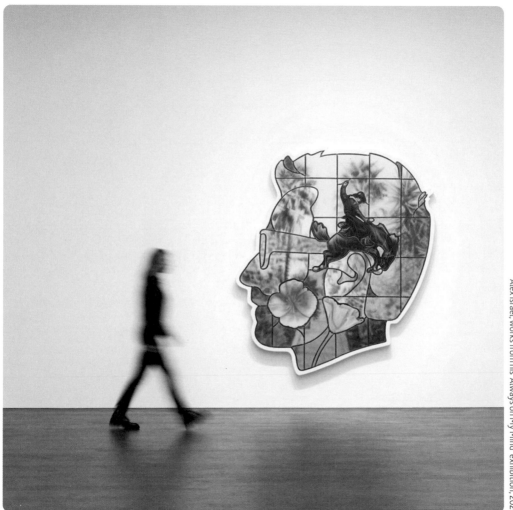

Alex Israel, works from his 'Always on My Mind' exhibition, 2020

⋆⁺ GAGOSIAN

MODERN/CONTEMPORARY ART

Tucked away in Mayfair, Gagosian is an ultra-modern, stark space run by art mogul Larry Gagosian. One of three sites in the British capital, it belongs to a network that stretches from New York to London to Athens, exhibiting prominent twentieth- and twenty-first-century artists. Larry Gagosian opened his first site in LA back in 1980, showcasing challenging artists of the time such as Jean-Michel Basquiat and David Salle. Over time, Gagosian exhibited works by more established artists, including Andy Warhol and Jeff Koons. And, more recently, the network has showcased works by Francis Bacon, Alex Israel, Pablo Picasso and even Rembrandt. Smaller galleries offer a chance to see a curator's skill at work and, as evidenced by 2020's 'Live in your Head: Richard Artschwager's Cabinet of Curiosities', this is something Gagosian does particularly well.

20 Grosvenor Hill, W1K 3QD
020 7495 1500
www.gagosian.com
Tues.–Sat. 10:00–18:00; free
Bond Street Tube

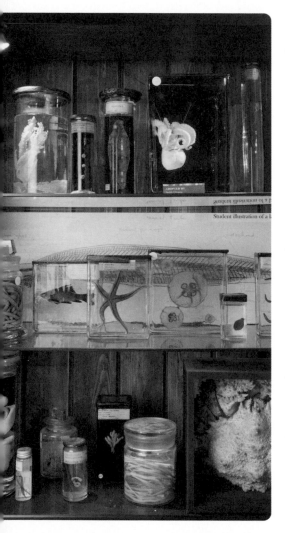

Student illustration of a [...]

✤ GRANT MUSEUM OF ZOOLOGY

NATURAL HISTORY

Part of University College London, the Grant Museum of Zoology looks like the curiosity shop of a mad Victorian scientist. Specimens are stuffed into jars and skeletons of long-forgotten mammals hang in glass-fronted cabinets. This is Victorian England's obsession with the pickled, pressed and preened on steroids. You may need a solid stomach to enjoy some of the exhibits, but a visit is definitely worthwhile. Weird highlights include a jar stuffed with eighteen perfectly preserved male moles, and a rickety skeleton of the now extinct quagga. One of the more fascinating exhibits is the brain gallery, which showcases the white matter of creatures from turtles to the domestic dog; check out the dissected dog's brain that has been scrutinised and annotated in minute detail. In all, 67,000 specimens stare down at you as you partake in this short and sweet experience. Combine the Grant Museum with a trip to the nearby Petrie Museum of Egyptian Archaeology (see page 44) for a full afternoon.

—

21 University Street, WC1E 6DE
020 3108 9000
www.ucl.ac.uk/culture/grant-museum-zoology
Mon.–Sat. 13:00–17:00; free
Goodge Street Tube

Hiro, 'Hiro' exhibition, 2018

❖ HAMILTONS GALLERY

PHOTOGRAPHY

Vulnerable faces taken by the greats of modern photography stare from the walls of this venerable gallery, in business since 1977. Along with The Photographers' Gallery (see page 45), Hamiltons is at the forefront of photography in London and represents such major players as Don McCullin, whose work has graced magazine covers and world-famous galleries worldwide. The gallery also sells works by Mario Testino and Annie Leibovitz, and has hosted prominent exhibitions by key artists. Testino's 'East' exhibition showcased images of vividly tattooed, entwined men shown alongside pictures of soft Japanese silks. Architectural retrospectives also feature, keeping the collection fresh and vibrant. The gallery itself is sleek, striking and intimate – you may well have the place to yourself when you visit. And, located in the heart of Mayfair, it's an antidote to the myriad of galleries specialising in modern painting.

—

13 Carlos Place, W1K 2EU
020 7499 9493
www.hamiltonsgallery.com
Mon.–Fri. 10:00–18:00, Sat. 11:00–16:00; free
Green Park Tube

✤ HAUSER & WIRTH
MODERN/CONTEMPORARY ART

With branches in London, New York, Zürich and (strangely enough) Somerset, Hauser & Wirth is one of the world's leading commercial galleries. The London branch is located on Savile Row, where an airy space houses some of the most exciting art exhibitions in the capital. As this is a commercial gallery, entry is always free. The gallery has its finger on the pulse in the art world (and super-friendly staff), and promotes a roster of modern artists both past and present. To celebrate 100 years since the founding of the German art school, the Bauhaus, 2019 saw a László Moholy-Nagy exhibition, while visual artist Geta Brătescu's work, the 'Power of the Line' was given a full show, too. Kids are welcome into the Hauser & Wirth gallery on the first Saturday of each month, and there are workshops related to the exhibitions, whether it involves painting or exploring objects that influence artists.

—

23 Savile Row, W1S 2ET
020 7287 2300
www.hauserwirth.com
Tues.–Sat. 10:00–18:00; free
Bond Street Tube

✦ HAYWARD GALLERY

MODERN/CONTEMPORARY ART

The brutalist Hayward Gallery on London's South Bank is home to some of London's biggest shows. It has no permanent collection, but presents three to four exhibitions a year. The focus is on contemporary art, although the gallery has also exhibited work by Leonardo da Vinci in the past. Bridget Riley, George Condo and Tracey Emin have all had big shows, while summer 2019's 'Kiss My Genders', about identity, was rave-reviewed. This is a space that's not afraid to push boundaries, which probably has a lot to do with the building's bold architecture. It was built by Higgs and Hill in 1968, as part of the Southbank Centre, which also includes the Royal Festival Hall and Queen Elizabeth Hall. This concrete behemoth was refused listed buildings status in the UK, but has made its way onto the World Monument Fund's protected list.

Belvedere Road, SE1 8XX
020 3879 9555
www.southbankcentre.co.uk
Daily, except Tues. 11:00–19:00
(Thurs. 11:00–21:00); ££–£££
Waterloo Tube & overland

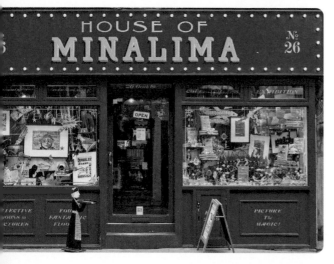

✤ HOUSE OF MINALIMA

GRAPHIC DESIGN

Wander into the House of MinaLima and you'll be struck by just how familiar everything seems. That's because this quirky space was founded by a design duo who created graphics for the Harry Potter films and the Fantastic Beasts series. Eduardo Lima and Miraphora Mina drew the Marauder's Map and designed packaging for Diagon Alley shops. And it's all on display in Soho. What started as a pop-up is now a permanent Harry Potter lover's paradise. The space is fabulously wonky. Walls are covered with film paraphernalia and posters, as well as props from all the Warner Bros. films the pair have worked on. Their merchandise is incredible. Buy a Hogwart's letter for the magical child in your life or some giftwrap featuring *Daily Prophet* news. A slice of magic in deepest Soho – go, browse and marvel.

157 Wardour Street, W1F 8WQ
020 3214 0000
www.minalima.com
Daily 12:00–19:00; free
Piccadilly Circus Tube

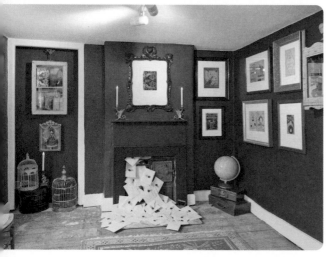

❖ HOUSEHOLD CAVALRY MUSEUM

MILITARY HISTORY

This is one of London's very few living museums. It's a place where members of the public can watch troopers tend to their horses through glass, and gain glimpses of the lives of real soldiers. You'll recognise the Household Cavalry from the soldiers and steeds in the Queen's Birthday Parade in June. Many of those who serve in the Household Cavalry have returned from posts abroad, and their lives are now dedicated to serving the Royal Family. The museum is just off busy Whitehall – blink and you'll miss it. Arrive early enough to see the horses being prepared for the day's events. Besides having a chance to watch the horses and riders, you'll learn about the intense training horses have to go through, and the work involved in preparing for big ceremonial events. Kids can try on bits of armour to sample what it feels like to be a rider, and the uniforms on display show how military fashions have changed over the years.

Whitehall, SW1A 2AX
020 7930 3070
www.householdcavalrymuseum.co.uk
Daily 10:00–18:00 (Apr.–Oct.), 10:00–17:00 (Nov.–Mar.);
£ (veterans and serving Household Cavalry personnel and their families free)
Westminster Tube

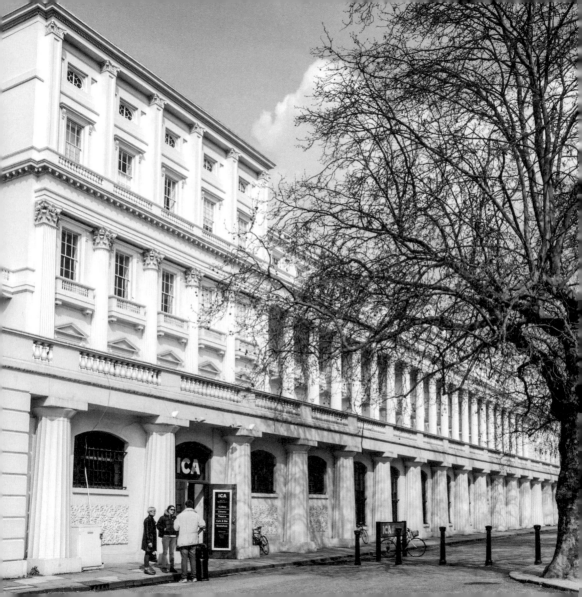

✤ INSTITUTE OF CONTEMPORARY ARTS (ICA)

<u>MODERN/CONTEMPORARY ART</u>

The ICA resides in the palatial Nash House, former home of Horatio Nelson, with its illustrious location on The Mall — the mile-long stretch of road that leads from Trafalgar Square to Buckingham Palace. Originally founded in 1947, the idea behind the ICA was to focus on innovation and creativity. Since its opening, Jackson Pollock has exhibited, Allen Ginsberg has spoken, Meyer Schapiro has given lectures, and Yoko Ono has participated in an exhibition. The centre continues to push boundaries and has an international outlook in its wide, white spaces. Films and talks take place alongside exhibits: screenings have included *Tehran: City of Love*, *Beanpole* (about life in postwar Leningrad), and *Mystify: Michael Hutchence*, a deep delve into the INXS frontman's life.

———

12 Carlton House Terrace, SW1Y 5AH
020 7930 3647
www.ica.art
Tues.–Thurs., Sun. 12:00–23:00, Fri.–Sat. 12:00–24:00; £ (Tues. free)
Charing Cross Tube & overland

Honey-Suckle Company, *Omnibus*, 2019

Metahaven, *VERSION HISTORY*, 2019

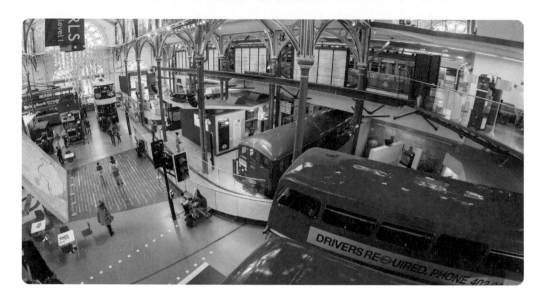

❖ LONDON TRANSPORT MUSEUM
SOCIAL HISTORY/TRANSPORT

Did you know that, in the 1850s, more people commuted through London via boat than by train? Or that the first Tubes on the London Underground were steam-operated, leaving passengers covered in soot if they stood on the platform for too long? You can learn about these things, and more, at London Transport Museum in Covent Garden. Set across three floors, the museum whisks you back to 1800 on the top floor and brings you downstairs through horse-drawn buses to electric vehicles.

The place is jam-packed with facts, stats and exhibits — many of them aimed at kids. Clamber on original Victorian trams and buses from the 1920s, or take a seat in a third-class Tube carriage and read the adverts. There's a play area where children can dress up and a city of the future exhibition that explores Crossrail and what a greener city looks like.

—

Covent Garden Piazza, WC2E 7BB
0343 222 5000
www.ltmuseum.co.uk
Daily 10:00–18:00; £££ (under 17s free)
Covent Garden Tube

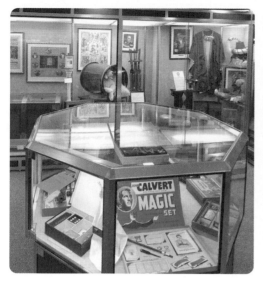

✤ MAGIC CIRCLE MUSEUM

<u>CULTURAL HISTORY</u>

The Magic Circle is the very definition of a secret society. Founded in 1905, membership is by invitation only and is reserved for the world's finest and most talented magicians. For mere mortals interested in tricks and sleights of hand, the Magic Circle Museum should sate some curiosity. There's plenty of ephemera from the history of magic – guns from bullet illusions and the cup-and-ball prop that Prince Charles used when he applied to join the Circle (gaining admission in 1975). The museum also reveals ways in which magic has been used in various real-life situations – for example, when the British Army employed a magician to help make the Suez Canal invisible to enemy bombers in 1941. Live-action magic is also on display: the museum has a theatre that holds intimate magic nights on which four magicians take to the stage with slots of about twenty minutes each.

—

12 Stephenson Way, NW1 2HD
020 7387 2222
www.themagiccircle.co.uk
Tours by appointment only, check website for details; £££
Euston Tube & overland

'Cathedral Block Prayer Stage Gun Stock' exhibition, 2019

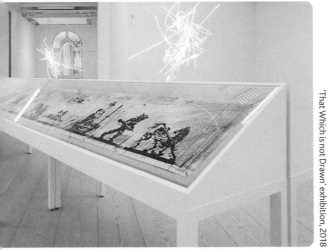

'That Which is not Drawn' exhibition, 2018

❖ MARIAN GOODMAN GALLERY

MODERN/CONTEMPORARY ART

Marian Goodman is one of the world's most influential gallerists. Located in three cities (London, Paris and New York), her galleries push the boundaries of what art is and means. The space in Soho, just south of Golden Square, is extraordinarily light and vast. White walls and industrial-style pillars are flooded with sunlight from the skylights, and the two floors allow plenty of room for the works to sing. Exhibitions have included controversial photographer Nan Goldin, famous for her black-and-white images of transwomen from the 1970s. Goodman showcases artists who could be described as leaders of their generation, such as visual artist Tacita Dean and abstract sculptor Richard Deacon. She attempts to achieve gender parity, too.

5–8 Lower John Street, W1F 9DY
020 7099 0088
www.mariangoodman.com
Tues.–Sat. 10:00–18:00; free
Piccadilly Circus Tube

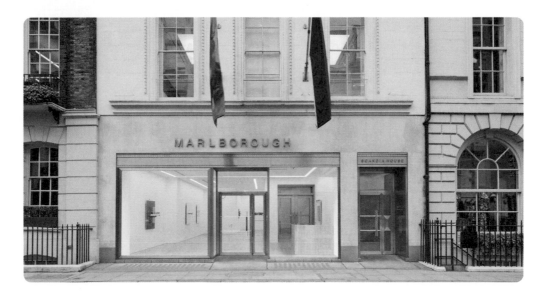

❋ MARLBOROUGH

<u>MODERN/CONTEMPORARY ART</u>

One of Central London's oldest art galleries, Marlborough was founded in 1946 by Frank Lloyd and Harry Fischer, initially focusing on nineteenth-century masters such as Auguste Renoir, Paul Signac and Camille Pissarro. However, this changed as the gallery matured and two other locations opened (New York's Lower East Side and Madison Avenue, although Marlborough has one location in New York today, in Chelsea). Exhibitions became decidedly more contemporary – Frank Auberbach, R.B Kitaj and Jackson Pollock were all invited to display their art. Stepping away from the Western hegemony that dominates most London galleries, Marlborough now exhibits contemporary Chinese art, too. Works by Paula Rego, Lucian Freud and Francis Bacon are among Marlborough's permanent collection and have all been loaned out for bigger shows. The gallery itself is a light-strewn space, dominated by huge, plate-glass windows.

—

Albermarle Street, W1S 4BY

020 7629 5161

www.marlboroughgallery.com

Mon.–Fri. 10:00–17:30, Sat. 11:00–18:00; free

Green Park Tube

✣ NATIONAL GALLERY

FINE ART

The National Gallery is London's big hitter. In the top four most visited art galleries in the world, it houses priceless works of art from the thirteenth century through to the modern day. Exhibitions have included beautifully curated shows from the Belle Epoque to twentieth-century Ed Ruscha. The National opened to the public in 1824, initially as a home for private donations, which make up two-thirds of the gallery's entire collections today. William Wilkins designed the original building – just one room deep – in the mid-1850s. Today, its architectural grandeur is a huge draw for visitors – all sweeping staircases, domed ceilings, long, tiled floors and intricate cupolas. During the Second World War, most of the gallery's paintings were evacuated to Wales. This is one of the few places in the world where visitors can see Picassos, Gauguins and Titians for free. Collection highlights include Vincent van Gogh's *Sunflowers*, Hans Holbein's *The Ambassadors*, and Van Eyck's *The Arnolfini Portrait*.

—

Trafalgar Square, WC2N 5DN
020 7747 2885
www.nationalgallery.org.uk
Daily 10:00–18:00 (Fri. 10:00–21:00); free
Charing Cross Tube

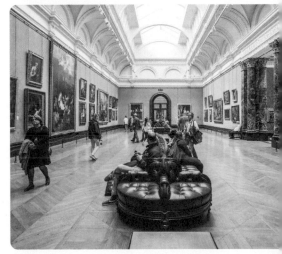

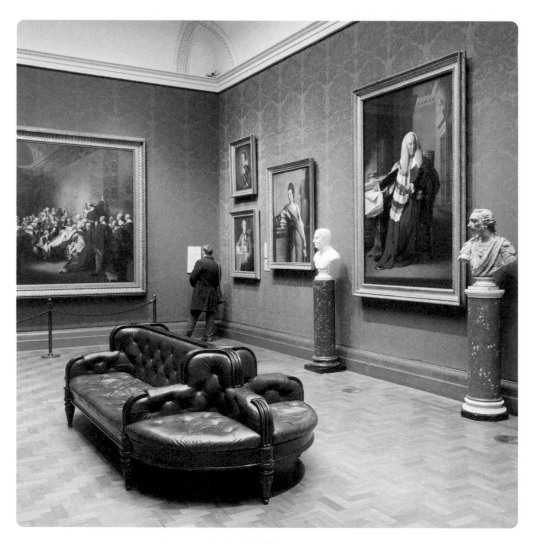

✤ NATIONAL PORTRAIT GALLERY

CULTURAL HISTORY/FINE ART/PHOTOGRAPHY

When the National Portrait Gallery opened in 1865, it was the first of its kind in the world. Stern Victorian figures stare down at you as you climb to the top floor, where some of the world's most famous paintings of Tudor monarchs live. There are 11,000 paintings in the collection, and more than 250,000 photographs. Among the best-known paintings are the Chandos portrait of William Shakespeare and majestic portraits of Queen Elizabeth I and Henry VIII by Hans Holbein. Most striking about the National Portrait Gallery is its dedication to displaying all aspects of British culture. The gallery continues to commission portraits, so you'll spot recent paintings of Kate Middleton and a portrait of Blur frontman Damon Albarn by Julian Opie, among many others. The building, close to Trafalgar Square, has a myriad of secrets. Its offices used to house a nightclub in which Audrey Hepburn once performed, and there's allegedly a secret passage that runs from the public building to the staff offices.

St Martin's Place, WC2H 0HE
020 7306 0055
www.npg.org.uk
Daily 10:00–18:00 (Fri. 10:00–21:00); free
Charing Cross Tube

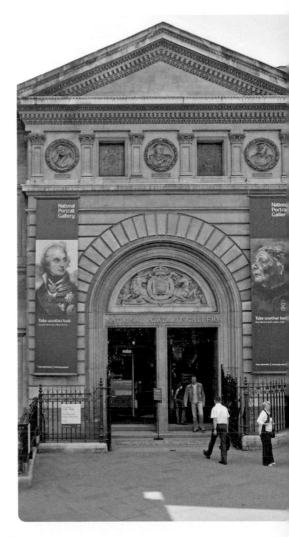

Adam Pendleton, 'Our Ideas' exhibition, 2018

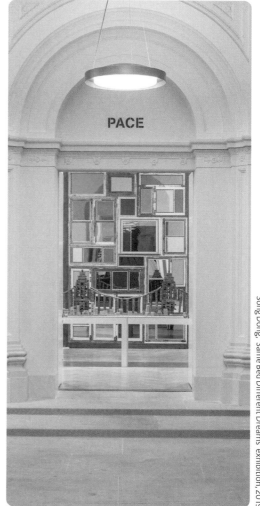

Song Dong, 'Same Bed Different Dreams' exhibition, 2019

"James Turrell" exhibition, 2020

✥ PACE GALLERY
MODERN/CONTEMPORARY ART

Pace Gallery represents many of the most significant international artists and estates of the twentieth and twenty-first centuries. Mark Rothko, Adam Pendleton, Loie Hollowell, Adrian Ghenie, Jean Dubuffet and Agnes Martin are just some of the names to conjure with. Exhibitions can be vivid and vibrant; for example, in 2017 the gallery played host to an immense display of interactive art created by teamLab, where visitors could stand under thundering waterfalls and in gardens of butterflies. Song Dong's 'Same Bed Different Dreams' exhibition featured a city made entirely from biscuits and sweets that visitors were encouraged to eat (a comment on the frailty of contemporary life). The London gallery joins onto the back of the Royal Academy of Arts (see pages 48–49) by Green Park and is one of seven worldwide. Other locations include two in New York – at 540 West 25th Street and 510 West 25th Street – as well as galleries in Palo Alto, Geneva, Hong Kong and Seoul.

—

6 Burlington Gardens, W1S 3ET
020 3206 7600
www.pacegallery.com
Tues.–Sat. 10:00–18:00; free
Green Park Tube

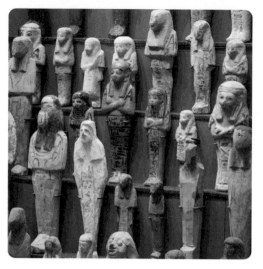

✤ PETRIE MUSEUM OF EGYPTIAN ARCHAEOLOGY

ANTIQUITY

Housed in University College London, the Petrie Museum of Archaeology has the aura of a stuffy Victorian university faculty space (it is) and is home to more than 80,000 objects. This is Flinders Petrie's collection. Up a narrow flight of stairs just off Malet Place, the rooms reveal the finds of the inexhaustible Egyptologist who spent many years of his life in the Sudan and Egypt. Children will love being handed a torch when they enter — you can't help but feel a little like Indiana Jones conducting your very own expedition. Some of the display cabinets are so dark that you need to crouch down to see the mummified hands or the world's oldest-known preserved woven garment. Peek at the world's first gynaecological document and even socks and sandals from the Roman period. This is a university museum, first and foremost, so expect stark white lights and the sort of barebones aesthetic found in academic institutions. But it's the content that counts, and this one's a stunner.

—

Malet Place, WC1E 6BT
020 3108 9000
www.ucl.ac.uk/culture/petrie-museum
Mon.–Sat. 13:00–17:00; free
Goodge Street Tube

✤ THE PHOTOGRAPHERS' GALLERY

PHOTOGRAPHY

Narrow, thin and packed with photographic gems over multiple floors, The Photographers' Gallery is the perfect antidote to crowded Oxford Street just metres away. Housed in an old textiles warehouse, the gallery presents work from world-famous photographers. Past exhibits have featured the work of Sebastião Salgado and Juergen Teller, as well as British photographers Martin Parr and Nick Knight. Many of the gallery's exhibitions celebrate London, a past show on hidden Soho pulling back the veil on sex shops and seedy underground bars. The gallery also supports pioneering works and causes, with focuses as diverse as abortion rights, environmental destruction, queer couplings, and life on the island of Cuba. During Thursday lates the gallery hosts talks, workshops and panel discussions. A highly browsable onsite shop sells prints and posters from various exhibitions.

16–18 Ramillies Street, W1F 7LW
020 7087 9300
www.thephotographersgallery.org.uk
Mon.-Sat. 10:00–18:00 (Thurs. 10:00–20:00),
Sun. 11:00–18:00; £
Oxford Circus Tube

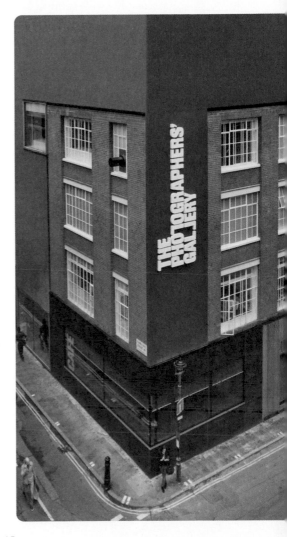

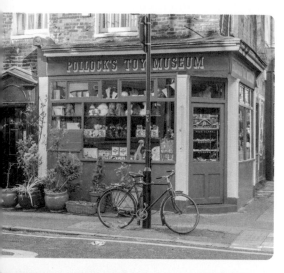

✤ POLLOCK'S TOY MUSEUM

CULTURAL HISTORY

Tucked away in Fitzrovia, Pollock's looks like a tiny shop, but push open the door and you'll be faced with a magical wonderland of toys. The pretty red and green exterior brings to mind the sort of toy shop Enid Blyton might have written about. Expect a labyrinthine exhibition of mostly Victorian pieces, from teddy bears to soldiers to toy theatres. Of particular note is a fine collection of playing cards – far more elaborate than today's boring black and red ones – while the room crammed with porcelain dolls will (possibly) terrify you. One of the best parts of this museum is that it's set within two fabulously creaky townhouses, so visiting feels like stepping back into a bygone time. Among the wooden blocks and old trains are a few real gems, such as the world's oldest teddy bear. There aren't many labels and, at times, it does feel a little like a personal collection housed in an old home, but this is all part of the charm. The museum is not suitable for very young children.

—

1 Scala Street, W1T 2HL
020 7636 3452
www.pollockstoys.com
Mon.–Sat. 10:00–17:00; £
Goodge Street Tube

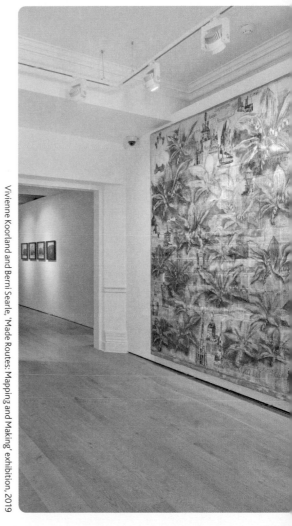

Vivienne Koorland and Berni Searle, 'Made Routes: Mapping and Making' exhibition, 2019

✣ RICHARD SALTOUN

CONTEMPORARY ART

Founded in 2012, Richard Saltoun's Mayfair gallery, with its boutique-style premises and collaborations with neighbouring designers such as Victoria Beckham, pushes the commercial art world to appreciate the importance and value of work by key historic figures of conceptual and feminist art. A report by Freelands Foundation showed female artists amounted to twenty-seven per cent of works sold in commercial galleries and Saltoun bucks this trend by actively focusing on important female artists in its roster of artists. The gallery ensures a rich programme of talks, workshops and film screenings that often spotlight art made by women and has established a strong reputation for shining a light on important international artists that include, among others, Renate Bertlmann, Annegret Soltau, Ulay and Helen Chadwick.

—

41 Dover Street, W1S 4NS

020 7637 1225

www.richardsaltoun.com

Tues.–Fri. 10:00–18:00, Sat. 11:00–17:00; free

Green Park Tube

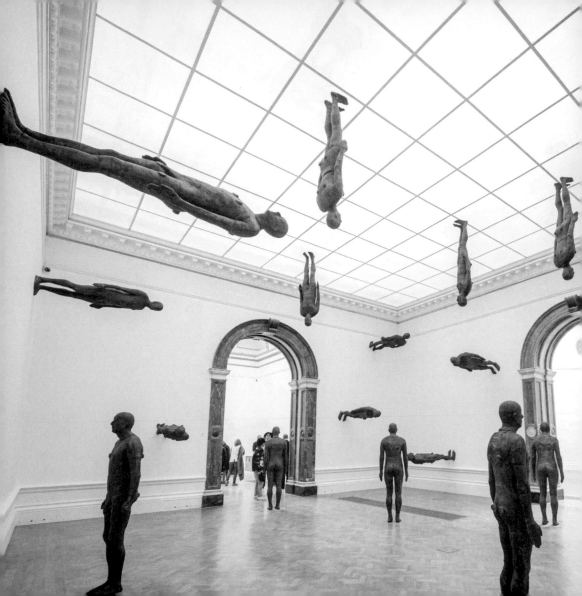

✛ ROYAL ACADEMY OF ARTS

FINE ART/CONTEMPORARY ART

With two main galleries — a space for a large, blockbuster show, and a smaller space upstairs — this pioneer of the visual arts has plenty of room to bring audiences in. There's rarely a duff note, and visitors often find themselves drawn to exhibitions they might not have considered previously. An exhibition of Battista Moroni's portraits offered an incredible contemporary insight into the sixteenth-century Italian painter's genius, while an Antony Gormley blockbuster saw the gallery transformed into an interactive space in which the artist challenged and stimulated visitors with his enormous sculptures. The gallery runs lates tied to the theme of each exhibition. They're often extravagant and it's smart to book a ticket well in advance. Following an extension as part of its 250th birthday celebrations, free temporary exhibitions on the ground floor also feature.

—

Burlington House, W1J 0BD
020 7300 8090
www.royalacademy.org.uk
Daily 10:00–18:00 (Fri. 10:00–22:00); £££–££££
Green Park Tube

✣ SIR JOHN SOANE'S MUSEUM
ANTIQUITY

At night, candlelight flickers in the hallway, illuminating a near-perfect reconstruction of this Georgian house museum. On some evenings, Sir John Soane's house stays open late for visitors wishing to explore its collection of Hogarth paintings and Roman statues out of hours. At Christmas, festivities offer glimpses of Georgian life, as well as mince pies, G&Ts and a one-hour tour of the house. Sir John Soane was a neoclassical architect and collector of antiquities, whose house ended up under the protection of Parliament because he disliked his son so much. He took pains to disinherit his son by stipulating that his house would belong to the state when he died. It's one of the city's most unusual museums. Only ninety people can visit at any one time, so be prepared to queue. There's scant information, low lighting and no cafe, but the interior is so surprising, and so unusual, with its domed ceilings, galleries and arches, that it's well worth the wait.

—

13 Lincoln's Inn Fields, WC2A 3BP
020 7405 2107
www.soane.org
Weds.– Sun. 10:00–17:00; free
Holborn Tube

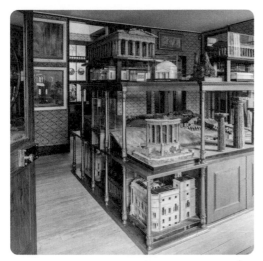

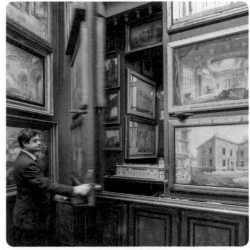

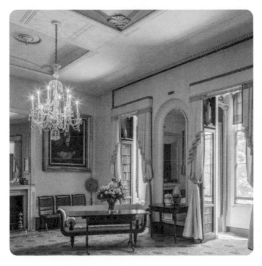

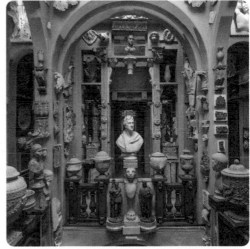

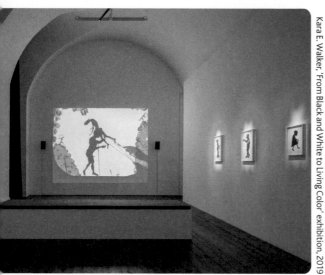

Kara E. Walker, 'From Black and White to Living Color' exhibition, 2019

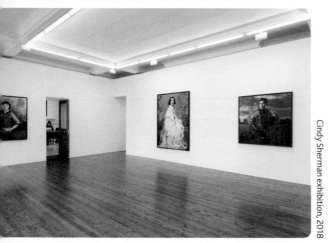

Cindy Sherman exhibition, 2018

✛ SPRÜTH MAGERS

MODERN/CONTEMPORARY ART

A leading contemporary commercial art gallery, Sprüth Magers also has venues in Berlin Mitte and LA's Miracle Mile. With work coming from more than sixty artists and estates, founders Monika Sprüth and Philomene Magers have close ties with the artists they represent, among them Cindy Sherman and Barbara Kruger. Tucked down a Mayfair side street, the gallery can feel quite hidden. Having mounted the stairs, push open the black door to reveal a warren of rooms displaying a variety of different media. Whatever happens to be on display, expect a beautifully curated explosion of modern art from this thirty-year-old enterprise.

—

7A Grafton Street, W1S 4EL
020 7408 1613
www.spruethmagers.com
Tues.–Sat. 10:00–18:00; free
Green Park Tube

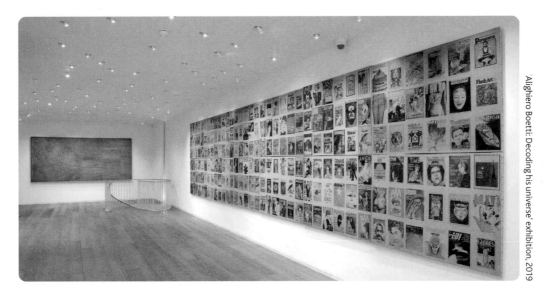

'Alighiero Boetti: Decoding his universe' exhibition, 2019

✥ TORNABUONI ART

MODERN/CONTEMPORARY ART

We may think we know everything there is to know about Italy's art scene, from Leonardo da Vinci to Carlo Carrà, but Tornabuoni Art introduces visitors to contemporary Italian artists, and specialises particularly in works from the second half of the twentieth century. The gallery was founded in 1981, in Florence. Today, the gallery also has venues in Milan and Paris as well as Florence and London. Every show at Tornabuoni Art is put together either by working closely with the artist, or with the artist's foundation, to ensure the work stays as truthful as possible to the artist's intention. Tornabuoni Art showcases work by artists such as Futurists Gino Severini and Giacomo Balla, as well as grand masters Giorgio de Chirico and Alighiero Boetti. In addition to Italian artists, works by Pablo Picasso, Joan Miró and Wassily Kandinsky all feature in the gallery's permanent collection.

—

46 Albemarle Street, W1S 4JN
020 7629 2172
www.tornabuoniart.com
Mon.–Fri. 10:00–18:00, Sat. 10:30–17:30; free
Green Park Tube

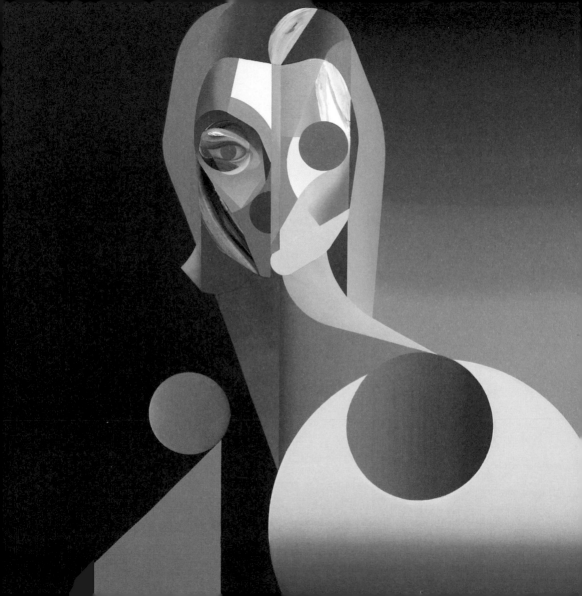

Jake Wood-Evans, *The Elue Boy, after Gainsborough I*, 2019

Dylan Gebbia-Richards, 'Kinesthesia' exhibition, 2019

Ryan Hewett, *Rise*, 2017–18

✤ UNIT

<u>CONTEMPORARY ART</u>

Every city needs a gallery like Unit, which strikes an uber-cool note with its black floors and stylish architecture. Plus, depsite the W1 address, Unit doesn't take itself too seriously. The gallery's original aim was to break down traditional elitist barriers in the art realm – not so easy in a world that is hierarchical and nepotistic. The gallery started as a pop-up in Chiswick, run by Joe Kennedy and Jonny Burt, who used social media to spread their message among millennials. Theirs is a gallery, a collective and a community that believes in the promotion and showcasing of truly gifted artists, regardless of their profile, reputation or background. This key message has resounded with collectors worldwide. The gallery now has two locations: in Mayfair and Covent Garden. Swing by the Mayfair gallery and you might get the chance to hang out with the owner's incredibly well-groomed Old English Sheepdog, Bear.

3 Hanover Square, W1S 1HD
020 7494 2035
www.theunitldn.com
Mon.–Sat. 10:00–19:00, Sun. 12:00–18:00; free
Bond Street Tube

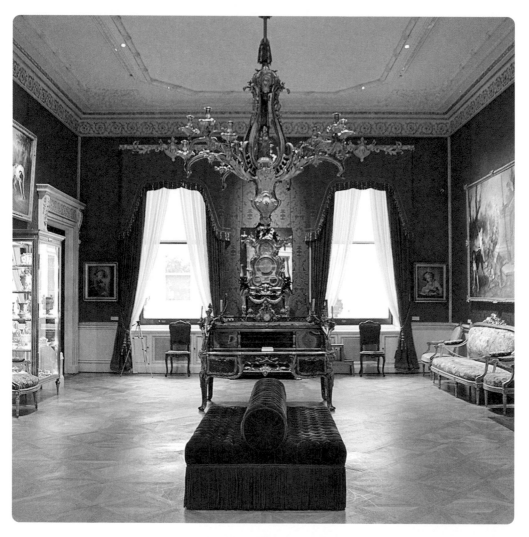

✤ THE WALLACE COLLECTION

SOCIAL HISTORY

Home to the Wallace Collection, Hertford House sits grand and stately just back from the road on Manchester Square and feels like a hidden palace in the centre of the city. As soon as you walk in, you'll be hit by the smell of freshly brewed coffee; at the back of the house, a large glass roof spans an inner courtyard, over a vibey restaurant. Within the main building, carpets are deep and plush, and various ornate clocks chime on the hour. A grand sweeping staircase leads up to the first floor, where stern paintings of earls and frolicking nymphs stare down at you. The collection was bequeathed to the nation by Lady Wallace and represents a curiosity, packed as it is with vases and paintings and fifteenth-century armour. The art is magnificent, with nine works by Rubens, five by Rembrandt and two Titians. That British stately homes are so full of Ancien Régime paintings owes much to the vast number of revolutionary sales after 1789, when impoverished noblemen flogged what they had in order to survive.

Manchester Square, W1U 3BN
020 7563 9500
www.wallacecollection.org
Daily 10:00–17:00; free
Bond Street Tube

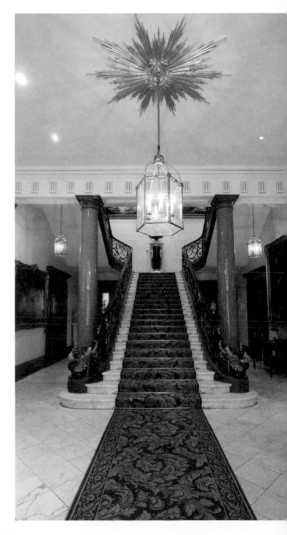

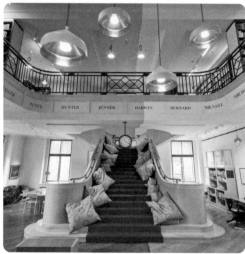

❖ WELLCOME COLLECTION

HEALTH AND MEDICINE

The Wellcome Collection has long been a venue for the squeamish to avoid and the curious to cherish. A museum about health, this is a vital and intriguing place to visit, and manages to demystify scary diseases by presenting practical information in fascinating yet no-nonsense terms. Among the more bizarre odds and ends are scary-looking forceps, false eyes and the world's first dildo. The collection was founded by a Victorian collector, Sir Henry Wellcome, who loved medical treasures. He also collected Napoleon's toothbrush and a used guillotine blade from the French Revolution, both of which are on show here. One of the most enticing things about the Wellcome Collection is its temporary exhibitions, always beautifully researched and packed with academic knowledge distilled into easy-to-absorb facts. Past shows have included the illusion of magic, how we play, and the impact of living in cities. Having taken in a host of gruelling facts, enjoy a slice of cake or some soup at the onsite Peyton and Byrne cafe.

—

183 Euston Road, NW1 2BE
020 7611 2222
www.wellcomecollection.org
Tues.–Sun. 10:00–18:00 (Thurs. 10:00–21:00); free
Euston Tube & overland

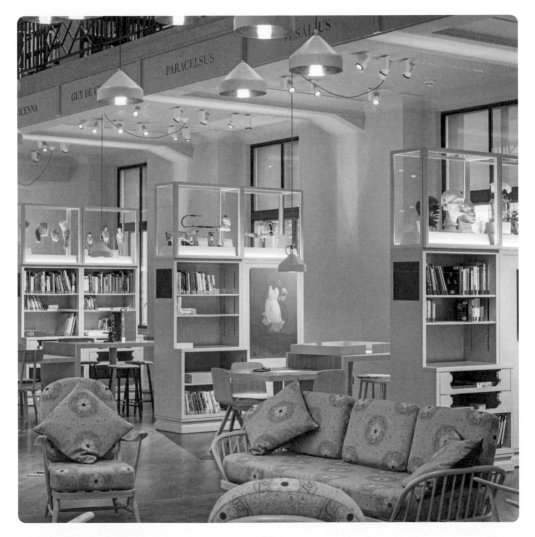

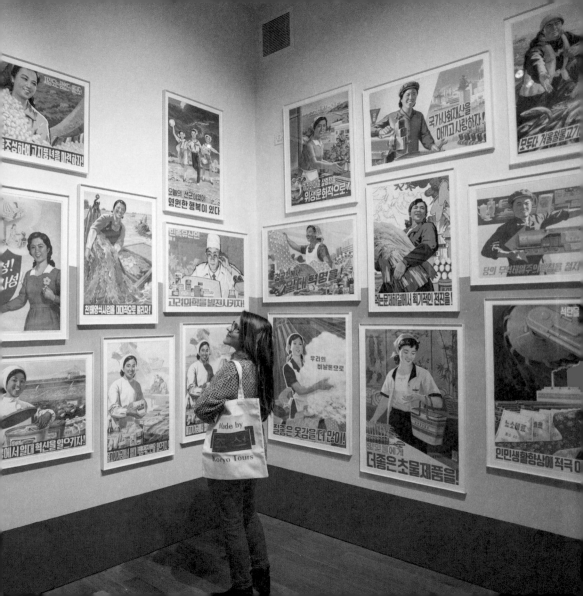

NORTH LONDON

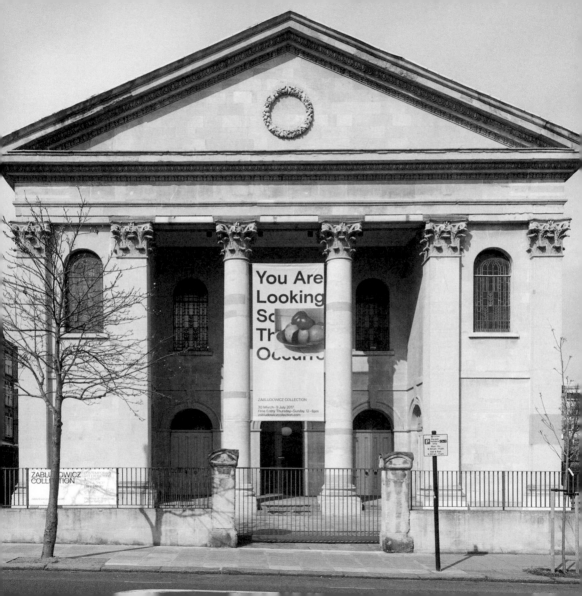

NORTH LONDON

North London, famous for its old punk scene and wild ways, is more residential and laid back today. Camden has turned its canal basin into a place to relax on summer evenings, while Hampstead and Highgate continue to function as genteel gates to London's wild heath. The museums and galleries that can be found in North London offer a diverse range of experiences. Compare the residences of Romantic poet John Keats and brutalist architect Erno Goldfinger, for example. A wonderful surprise is the Estorick Collection of Modern Art, housed in what looks like an old stately home, while the Jewish Museum hints at North London's rich cultural heritage. Other highlights include the House of Illustration, the Vagina Museum, and the contemporary art of Victoria Miro and the Zabludowicz Collection (opposite).

✤ 2 WILLOW ROAD

ARCHITECTURE/DESIGN

In 1939, architect Erno Goldfinger built three houses on Willow Road, Hampstead, one of which (Number 2) he designated as his family home. The largest of the three houses, it features a spiral staircase designed by engineer Ove Arup. Although Goldfinger is most famous for tall, brutalist architectural designs that include West London's Trellick Tower, he was also a dab hand at designing furniture, and many of the pieces on display in this light-filled house are his creations. There is also a fabulous Modernist art collection, with works by Henry Moore, Max Ernst and Bridget Riley, among others. This is a National Trust property and quite small, so only a few visitors are allowed in between the hours of 15:00 and 17:00. Expect queues in high season.

2 Willow Road, NW3 1TH

020 7435 6166

www.nationaltrust.org.uk/2-willow-road

Weds.–Sun. 11:00–17:00; hourly tours from 11:00–15:00;

£

Hampstead Heath overland

Amedeo Modigliani, *Dr Francois Brabander*, 1918

Umberto Boccioni, *Modern Idol*, 1911

✤ ESTORICK COLLECTION OF MODERN ART

MODERN ART

Imagine a gallery crammed with works solely from twentieth-century Italy, a building stacked with Modiglianis, Ballas, Severinis, de Chiricos and Boccionis. Luckily, such a place exists. The Estorick, in the heart of Islington, brings together some of the most important art from twentieth-century Italy, with pieces from the Futurist movement and the Novecento movement among them. Paintings include Giacomo Balla's *The Hand of the Violinist* and Gino Severini's *The Boulevard*. The collection arose from the passion of art collector Eric Estorick, who became obsessed with the Futurists. He travelled to Italy, befriending artists practising in the 1940s and 1950s and buying their works. The Estorick is the fruit of his labours. As an added bonus, the Estorick Caffè serves exceptional Italian food and there's a bookshop specialising in publications on Italian art.

39a Canonbury Square, N1 2AN
020 7704 9522
www.estorickcollection.com
Weds.–Sat. 11:00–18:00, Sun. 12:00–17:00; £
Highbury & Islington Tube

❖ HOUSE OF ILLUSTRATION

GRAPHIC DESIGN

Illustration can evoke strong memories. Perhaps you remember Quentin Blake's iconic sketches in Roald Dahl's children's stories or the original covers of the Harry Potter novels? While illustration is often underappreciated as an art form, this gallery in King's Cross's Granary Square elevates it beyond postcards and books. Sir Quentin Blake founded the gallery, so expect work showcasing Sophie's journey on the BFG's shoulders or Matilda moving pencils in her school classroom. Exhibitions turn over frequently enough to keep you wanting to come back — nine per year across three gallery spaces. There's a political slant to some exhibitions, too. One past show looked at how graphic art was used across Cuba, while another charted black American lives and deaths using infographics. The House of Illustration runs a residency for illustrators and graphic artists and hosts London's largest free illustration fair in winter.

—

2 Granary Square, N1C 4BH
020 3696 2020
www.houseofillustration.org.uk
Tues.–Sun. 10:00–17.30; £
Kings Cross Tube & overland

Corita Kent, 'Power Up' exhibition, 2019

✤ JEWISH MUSEUM

CULTURAL HISTORY

Did you know that Torah scrolls are topped with decorative crowns – silver jangly bits that get removed before the Rabbi reads from the scroll? And that Torahs written in different countries have different shapes and designs on these crowns? Italy, for example, celebrates its musical heritage with crowns carved with violins. Among other objects, a number of these are on display at the Jewish Museum, a celebration of British Jewish heritage and the only museum in London dedicated to a minority living in the United Kingdom. The museum's exhibitions embrace different aspects of Jewish culture, and have included portrait displays as well as a show celebrating Jewish humour in the past. Besides contemporary exhibitions focusing on Jewish culture, there's a moving Holocaust gallery and the earliest example of a British Hanukkah menorah, known as the Lindo lamp.

—

Raymond Burton House, 129–131 Albert Street, NW1 7NB
020 7284 7384
www.jewishmuseum.org.uk
Sat.–Thurs. 10:00–17:00, Fri. 10:00–14:00; £
Camden Town Tube

✦ KEATS HOUSE

CULTURAL HISTORY

It's strange to think that a man who died aged just twenty-five could live in such a bucolic, perfect little cottage. But this is where Romantic poet John Keats lived; not in a bachelor pad in the centre of the city, but in a neat white house with fruit trees and a lawn. Originally invited to live here as a lodger before he left for Rome in 1820, Keats composed several of his most famous poems in the garden here, including *La Belle Dame sans Merci*. The house is now a museum that celebrates his life and work. Given that he died so tragically young from tuberculosis, he did not have many possessions, but you'll see his death mask and original manuscripts among the exhibits. In summer months, you can imagine young Keats strolling around the grounds here. He allegedly wrote *Ode to a Nightingale* sitting under the garden's plum tree.

—

10 Keats Grove, NW3 2RR
www.keatsfoundation.com
Weds.–Sun. 11:00—17:00; £
Hampstead Heath overland

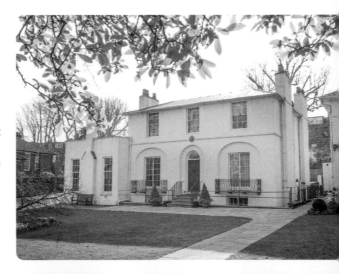

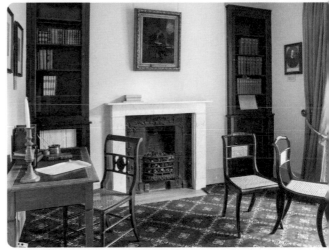

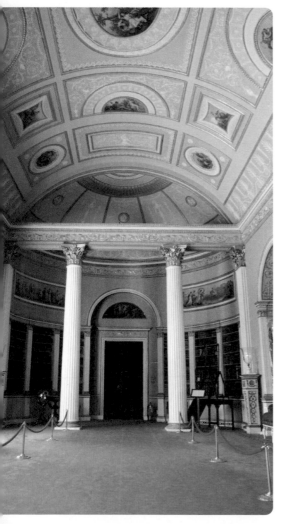

✤ KENWOOD HOUSE

ARCHITECTURE/DESIGN

Tucked away in beech woodland next to North London's Hampstead Heath, this former stately home is set in landscaped gardens with a picturesque pond. The house itself is a Palladian masterpiece. With architecture and interiors designed by Robert Adams and beautifully restored to their Georgian opulence, the rooms are boldly decorated and drenched in light. Imagine you're in a Jane Austen novel as you walk from room to room in search of Rembrandt's *Portrait with Two Circles*. Works by Gainsborough and Turner also hang here. Of particular note is the cute dairy house, which occupant George Saunders built for his wife in the 1790s. It was fashionable at the time for aristocratic women to have playthings, and dairies were one of them. Although it was a fully functioning space (providing the house with all the butter, milk and cream it needed), the building still had a quaint octagonal tea room where his wife Louisa entertained her friends. If exploration makes you peckish, stop off at the cafe and order cake. They do it very well here indeed.

Hampstead Lane, NW3 7JR
0370 333 1181
www.english-heritage.org.uk/visit/places/kenwood
Daily 10:00–16:00; £££
Hampstead Heath overland

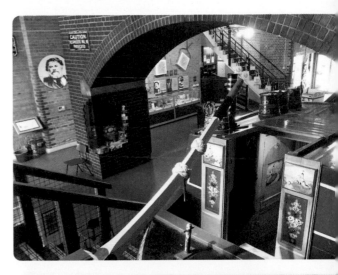

✤ LONDON CANAL MUSEUM

TRANSPORT

Before railways, Britain relied heavily on a network of canals for transporting materials and goods across the country. Carthorses pulled the barges initially, and later motors. Charting the city's canal history, the London Canal Museum has two strands. The first, as a waterways museum, explores how workers lived and worked on the canals. You'll learn about the Regent's and Grand Junction canals, and the engineering involved in making them – how, over 200 years ago, people dug them by hand, for example. The second strand, as an ice museum, reveals how the Victorians brought ice by ship from Norway and transported it to wealthy households and luxury restaurants by canal. The museum even has a deep ice well that you can peer into.

—

12–13 New Wharf Road, N1 9RT

020 7713 0836

www.canalmuseum.org.uk

Daily 10:00 to 16:30; £

King's Cross Tube & overland

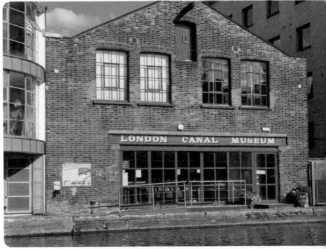

✤ THE POSTAL MUSEUM

SOCIAL HISTORY

The Mail Rail is a railway that runs under Mount Pleasant, where the old post office HQ was. And the best news? You can ride it, hurtling through London's dark underground in a tiny train that once carried letters to stations and sorting offices between Whitechapel and Paddington. The Postal Museum is one of London's best-kept secrets. With more than 60,000 objects in its collection, the museum spans 400 years of history, and covers topics such as the world's first postage stamp, pillar boxes and horse-drawn letter-carrying coaches. There is (obviously) an extensive stamp collection and cat lovers will adore the display on post-office cats — officially hired in 1868 to catch mice, earning one shilling a week. If you're bringing kids, they'll love playing at sorting post and working behind the glass dividers organising mail in the Postal Museum's miniature town.

—

15–20 Phoenix Place, WC1X 0DA
0300 0300 700
www.postalmuseum.org
Daily 10:00–17:00; £££
Farringdon Tube

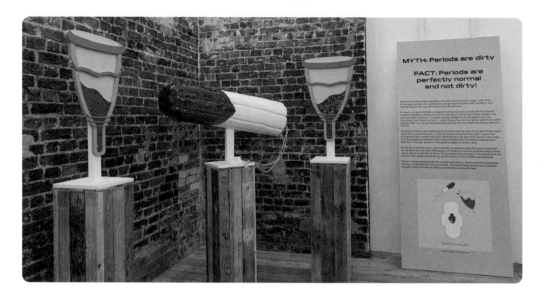

❖ VAGINA MUSEUM

SOCIAL HISTORY

The Vagina Museum opened in a bid to spread knowledge, erase stigma around women's bodies and to promote 'intersectional, feminist and trans-inclusive values'. Like the Penis Museum in Iceland, this claims to be a world first. The museum's 'Muff Busters' exhibition refutes many myths about the vagina. How should it smell or look? Is it really self-cleaning? Why are we so afraid of it? Initially a touring exhibition, the museum now resides in Camden Market, where a host of vagina-related artefacts are on display. In this respect, the museum plays a vital educational role, since – as one surprising piece of wall text notes – more than half of Britons can't accurately identify what or where the vagina is. The museum hosts a diverse range of events, from pub(e) quizzes to stand-up comedy and a 'cliterature' book club. Keep an eye on the museum website for workshops (clitoris Christmas baubles anyone?) and more.

—

Unit 17 & 18 Stables Market, Chalk Farm Road, NW1 8AH

020 3715 8943

www.vaginamuseum.co.uk

Mon.–Sat. 10:00–18:00, Sun. 11:00–18:00; free

Chalk Farm Tube

✤ VICTORIA MIRO

CONTEMPORARY ART

Victoria Miro's Islington gallery is stand-out, mostly because she represents the most intriguing artists – both established and emerging. The gallery might have a Grayson Perry exhibit, followed closely by Yayoi Kusamas' dazzling 'Infinity Mirrors' show. Established in a former Victorian furniture factory, this deceptively large gallery is set over two floors. There's also a pretty landscaped garden, which is a gorgeous place to sit out in during the summer. Founder Victoria Miro initially sought new talent direct from art schools and represents a solid, yet eclectic, mix of artists that include Doug Aitken, whose play with lights, colours and mobiles creates an astonishing psychedelic feel to a space. His exhibition, 'Return to the Real' explored our 'rapidly changing relationships to one another and the world around us in an age dominated by technology'. Every exhibition here conveys a strong message as well as being aesthetically interesting.

—

16 Wharf Road, N1 7RW
020 7336 8109
www.victoria-miro.com
Tues.–Sat. 10:00–18:00; free
Angel Tube

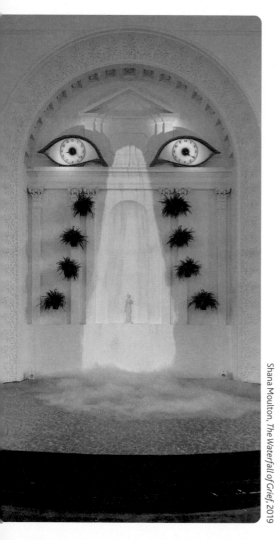

Shana Moulton, *The Waterfall of Grief*, 2019

✤ ZABLUDOWICZ COLLECTION

CONTEMPORARY ART

The first thing that will strike you about Anita Zabludowicz's collection is its magnificent setting in an old Methodist chapel that's saturated with light. Describing itself as a 'living collective', this Chalk Farm gallery aims to host three shows per year, celebrating experimental work by emerging artists. The gallery is fuelled by Zabludowicz's love of art: since 1990, she and her partner have amassed 5,000 works from 500 different artists. If you're into cutting-edge installation pieces, this gallery will tick all your boxes. Shows have included the mesmerising 'Whispering Pines' by Shana Moulton, who uses neon and retro sculpture to depict growing up on a Yosemite trailer park run by her parents, and Florian Meisenberg's interactive VR installation 'Pre-Alpha Courtyard Games'. The dedication to exploring new artistic forms should be exciting for visitors wanting to push their own experiences of art.

—

176 Prince of Wales Road, NW5 3PT
020 7428 8940
www.zabludowiczcollection.com
Thurs.–Sun. 12:00–18:00; free
Chalk Farm Tube

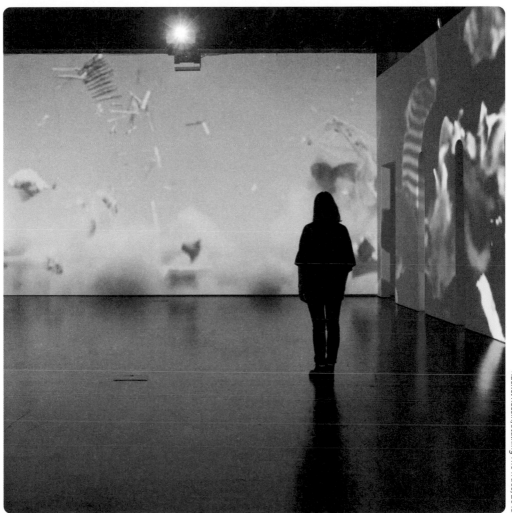

Rachel Rossin, *Stalking The Trace*, 2019

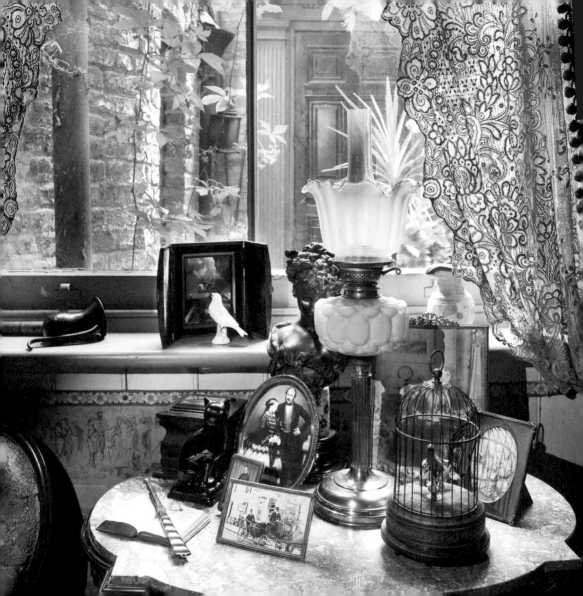

EAST LONDON

Dennis Severs' House

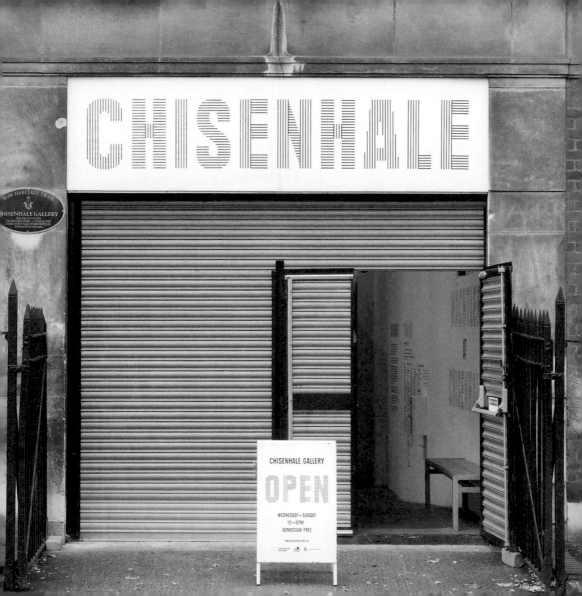

EAST LONDON

From gritty to gentrified in less than a decade, parts of London's
East End can feel as polished as its more established western counterpart
these days. Yet, there are still fascinating slivers of life to be found, and a whole
lot of heritage that can be witnessed through its museums and galleries.
Challenging shows have popped up in abandoned warehouses – now flooded
with light – with Chisenhale and Whitechapel galleries leading the march.
Less conventional still is the Viktor Wynd Museum of Curiosities. The East
End proper extends out from Clerkenwell and the City of London. Often
dead quiet at weekends, this ancient warren of streets is a pleasure to explore,
and is home to the long-established Museum of London and the Barbican
Centre. Elsewhere in this neighbourhood, you'll find spaces large
and small celebrating the home, childhood, education,
the Metropolitan Police, and more.

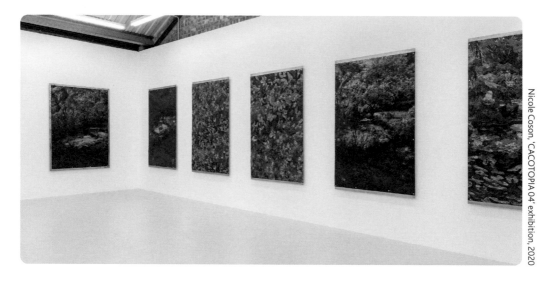

Nicole Coson, 'CACOTOPIA 04' exhibition, 2020

✤ ANNKA KULTYS GALLERY

CONTEMPORARY ART

Operating since 2015, and tucked away up a steep staircase in hipsterfied Bethnal Green, Annka Kultys' one-roomed gallery is a powerhouse of modern. When you visit, Annka may well bound down the stairs to open the door to you herself, beaming. And so she should. Her pocket-sized gallery hosts cleverly curated exhibitions by one leading contemporary artist at a time. Works exhibited are sometimes snapped up by bigger galleries, including Tate Modern. The exhibition rotation is frequent – Annka hosts as many as six solo shows a year, some of which include live performances. Past exhibitions have included the work of London-based Filipino artist Nicole Coson, the simulated spaces of Dane Stine Deja and performance art by American 'Reality Artist' Signe Pierce. Annka is committed to encouraging graduates, and supports solo shows of artists who have recently completed their degrees. If you're in the area, take a detour up the staircase, and brace yourself for the future of art.

—

472 Hackney Road, Unit 3, 1st floor, E2 9EQ
020 3302 6070
www.annkakultys.com
Thurs.–Sat. 12:00–18:00; free
Bethnal Green Tube

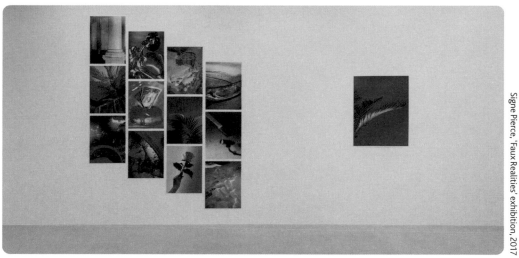

Signe Pierce, 'Faux Realities' exhibition, 2017

Stine Deja and Marie Munk, 'Synthetic Seduction' exhibition, 2018

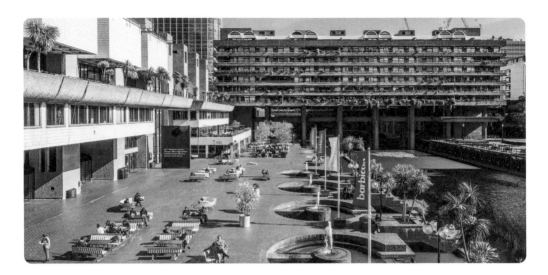

✤ BARBICAN CENTRE

MODERN/CONTEMPORARY ART

This brutalist concrete structure penetrates the London sky with its jagged corners and strong aesthetic. It's a cultural maze: go, and you might find yourself stumbling upon an interactive dance exhibit, an international orchestra or a beautifully curated series of photographs from around China. The Barbican estate was developed after the Second World War, and its startling design is at odds with the older, classical structures that surround it. In 2003 the Barbican was voted the city's ugliest building; it can certainly be one of the most difficult to navigate. Set over two floors, the art gallery here has the space to display complex themes. Recent highlights include an exploration of queer relationships in music, art and literature and a show about cabaret in the twentieth century. Alongside a photographic exhibit and piped music, the show included reconstructions of venues such as Zürich's Cabaret Voltaire and Le Chat Noir in Paris in their heyday.

—

Silk Street, EC2Y 8DS

020 7638 8891

www.barbican.org.uk

Mon.–Sat. 9:00–23:00, Sun. 11:00–23:00, Bank Holidays 12:00–23:00; ££–£££

Barbican Tube

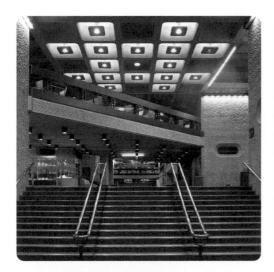

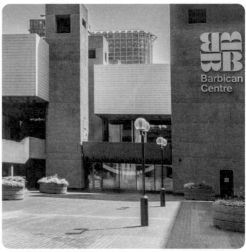

Ima-Abasi Okon, *Infinite Slippage*, 2019

❖ CHISENHALE GALLERY

<u>MODERN/CONTEMPORARY ART</u>

From the outside, Chisenhale Gallery looks exactly how you'd expect a cutting-edge, forward-thinking gallery to look. A former veneer factory, the space inside is big and white, allowing the art to take centre stage. The gallery was founded in the early 1980s to give artists the chance to be a little more experimental. It celebrates risk-taking, while also being home to some pretty outstanding works of art. In addition to the art on display, the gallery hosts a roster of talks and workshops to accompany the pieces so you can learn about the modern art world during your visit. The Chisenhale has hosted some big-name artists, too. Rachel Whiteread, whose work has since appeared at the Tate, had her first solo show here, in 1990 – a solid cast of the inside of a room from a Victorian terraced house. Her exhibition demonstrated the boundaries Chisenhale pushed and continues to do so two decades later.

64 Chisenhale Road, E3 5QZ
020 8981 4518
www.chisenhale.org.uk
Weds.–Sun. 12:00–18:00; free
Bow Tube

✤ CITY OF LONDON POLICE MUSEUM
SOCIAL HISTORY

This quirky little museum presents a look at some key moments in London's gruesome criminal history. It also provides an insight into what life as a member of the police force has been like through the past few centuries. Consider evidence from Jack the Ripper's case by taking a fascinating (if gruesome) look at the life of one of his victims, Catherine Eddowes. And read stories about how the police dealt with times of crisis such as during the Blitz. You'll discover lesser-known facts about London's crime-ridden past; the Houndsditch

Murders, a tragic early-twentieth-century situation in which three policemen were shot and killed is explored here, for example. If you're into vehicles, there's also a collection of retro police ambulances. Not easy to find, the entrance to the museum is located on the corner of Aldermanbury and Gresham Street.

—

2 Aldermanbury, EC2V 7HH
020 7332 1100
www.cityoflondon.police.uk
Mon.–Fri. 9:30–17:30 (Weds. 9:30–19:30), alternate Sats.
10:00–16:00; free
Barbican Tube

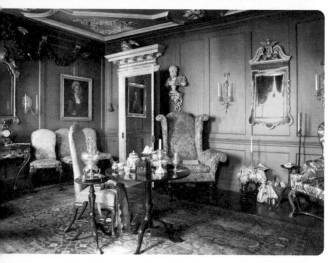

❖ DENNIS SEVERS' HOUSE
SOCIAL HISTORY

For twenty years (1979–1999), American Dennis Severs lived in a former Huguenot's house on Folgate Street near Spitalfields, which he transformed into the home of eighteenth-century silk weavers. Today, red-shuttered windows give way to a life that feels frozen in time. Revealing different layers of the area's history, rooms are crowded with exhibits from the period and still-life drama. Half-eaten loaves of bread sit on tables and the rooms are filled with appropriate background noises, and even smells. This utterly remarkable museum leaves you feeling as if you've visited a foreign country, but one familiar enough to remind you of your own. Note that the house has very limited opening times to help keep it intact. Check the website for information about special openings in the evenings, too.

—

18 Folgate Street, E1 6BX
020 7247 4013
www.dennissevershouse.co.uk
Mon. 12:00–14:00, Sun. 12:00–16:00; £
Liverpool Street Tube & overland

✤ GUILDHALL ART GALLERY

FINE ART/ANTIQUITY

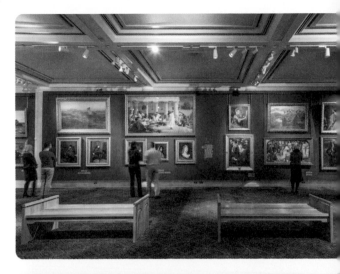

One thing you don't expect to find when you're casually entering an art gallery packed with Romantic paintings, is London's Roman Amphitheatre. While much is left to the imagination if you are to picture gladiators fighting to the death here, the fact that you can visit the site at all, deep in the bowels of this building, is impressive. Upstairs, a strong collection of pre-Raphaelite and Orientalist paintings awaits. There are 250 paintings on display, some of which feature London as their theme. After all, the gallery, which is part of the Guildhall School of Music and Drama, was originally developed to house the City of London's growing art collection. While the original building was destroyed during a Second World War air raid, the collection had already been taken to Wiltshire for safety.

—

Guildhall Yard, EC2V 5AE

020 7332 3700

www.cityoflondon.gov.uk/things-to-do/visit-the-city/attractions/guildhall-galleries

Mon.–Sat 10:00–17:00, Sun. 10:00–16:00; free

Moorgate Tube

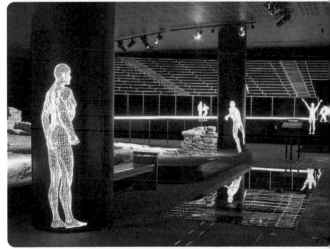

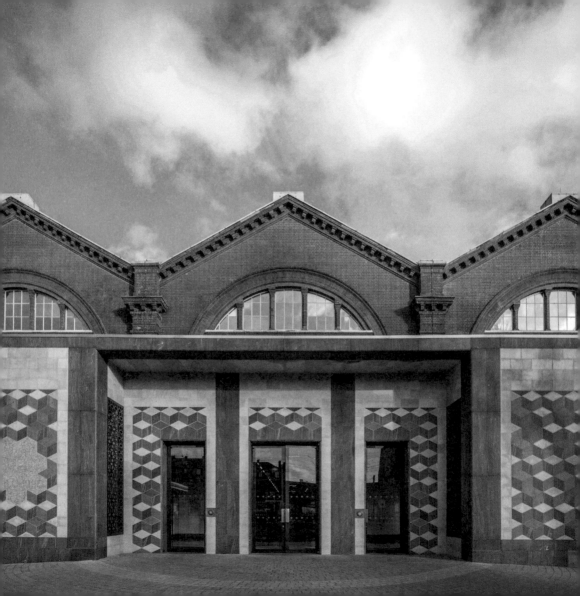

✛ MUSEUM OF CHILDHOOD

SOCIAL HISTORY

An offshoot of the V&A empire, Bethnal Green's Museum of Childhood is packed with toys, trinkets and train sets, and is the largest museum of its kind in the world. From original Barbie dolls to tin racing cars, it's eye-opening to see how children's lives have changed over the centuries. Touring the museum, you'll see just as many baby boomers cooing over old train sets as you will young kids trying to spin a hoop. The museum's collection of dolls' houses is particularly staggering. It has more than 100 different houses, including Mrs Bryant's Pleasure, modelled on her own luxurious, middle-class lifestyle in Surbiton from 1865. Most of the furniture in the house was commissioned from a cabinetmaker and gives us an incredible insight into Victorian domesticity. The space feels more like an ancient, iron train station than a stuffy museum. And the cafe is a great place to have some cake and put your feet up after exploring.

Cambridge Heath Road, London E2 9PA
020 8983 5200
www.vam.ac.uk/moc
Daily 10:00–17:45; free
Bethnal Green Tube

✤ MUSEUM OF THE HOME

SOCIAL HISTORY

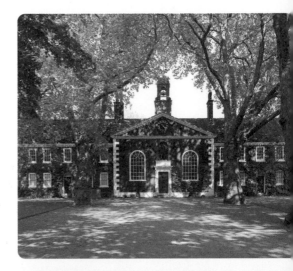

Fans of houses and social history will love the Museum of the Home, formerly known as the Geffrye Museum. Recently reopening following extensive renovation, this museum provides a snapshot of how the home has changed over the centuries. Our concept of 'home' has remained the same for many years – we still need beds and chairs and places to wash – even if the style of these items has evolved. Showcasing a room for each of several periods from 1630 to 1990, the museum's spaces are packed with period details. More recent additions to the collection weave in various cultural narratives, from that of an asylum seeker to that of a monk who has spent the last twenty years living inside his temple in London. Set just off East London's bustling Kingsland Road, the Geffrye almshouses that house the museum have a stunning herb garden to the rear and loop around a big grassy open courtyard to the front. This is sometimes busy with seasonal fairs, so stop by in winter for a mug of mulled wine.

136 Kingsland Road, E2 8EA
020 7739 9893
www.museumofthehome.org.uk
Opening hours tbc; free
Hoxton overland

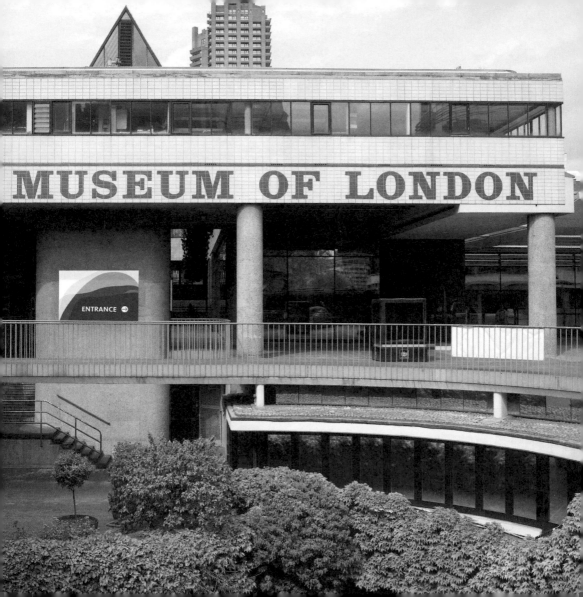

✤ MUSEUM OF LONDON

<u>CULTURAL HISTORY</u>

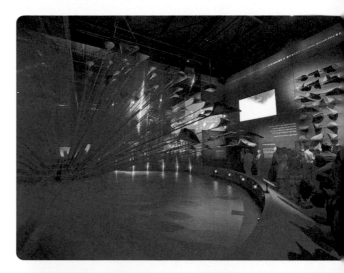

Documenting London from prehistoric to modern times, this brilliant, interactive museum is aimed at both kids and parents alike – expect lots of dressing up, games and eyewitness accounts. Did you know, for example, that 125,000 years ago, London had the same biosphere as America's Great Plains and hippos lived in what is now Trafalgar Square? Or that, under the Romans, Londinium was the largest city in the world and remained that way for 1,000 more years? There are plenty of axe-heads and tales about life in those days. Besides a walk through the city's history, the museum looks at life in London during times of hardship, such as the Great Plague of 1665 and the Blitz of the Second World War. Past exhibitions have taken a peek into the world of animals in the city and forty years of the band, The Clash.

—

150 London Wall, EC2Y 5HN
020 7001 9844
www.museumoflondon.org.uk
Daily 10:00–18:00; free
Barbican Tube

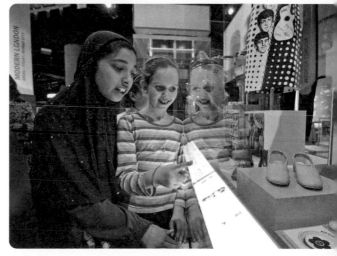

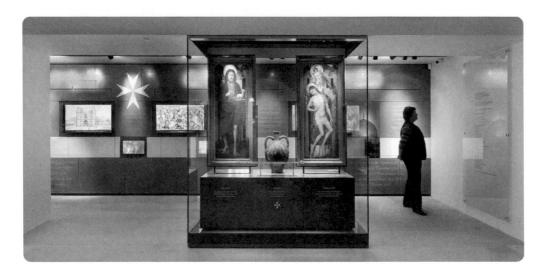

✤ MUSEUM OF THE ORDER OF SAINT JOHN

HEALTH AND MEDICINE

Despite its mysterious-sounding name, this museum is a member of the London Museums of Health and Medicine. Housed in a sixteenth-century Clerkenwell gatehouse (St John's Gate), the order's origins date back to the Crusades and caring for sick pilgrims in eleventh-century Jerusalem. It's only fitting that a charity with such origins should have some exceptional items on display. A bronze cannon given to the order by Henry VIII, rare armour and illustrated manuscripts are all on display, while there are also a number of paintings showing the order's wards and nursing stations at various conflicts. A particularly fascinating film archive offers glimpses into conflict during the Second World War and the Gulf Wars. Additional highlights include the Tudor gatehouse, a peaceful crypt and the black and white tiled Priory Church. The museum offers several dedicated tours, so be sure to check the website when planning a visit.

—

St John's Gate, St John's Lane, EC1M 4DA
020 7324 4005
www.museumstjohn.org.uk
Mon.–Sat. 10:00–17:00; free
Farringdon Tube

✛ QUEEN ELIZABETH'S HUNTING LODGE

<u>CULTURAL HISTORY</u>

Built back in 1543, originally for Elizabeth I's father, Henry VIII, this hunting lodge stands in the centre of Epping Forest, where you can imagine the young princess leaping onto her horse and galloping away in search of deer. Legend has it that she even rode her horse up the interior stairs. The renovated and informative museum has quizzes and brass rubbings available for children, and a fully working Tudor kitchen, where you can see how the queen would have been fed and entertained when she stayed here for a hunt. The first floor of the lodge is devoted to the history of Elizabethan fashion, and you (or the kids) can try on replicas and imagine what it was like to wear ruffs and long dresses all day. The lodge is great for visiting with children, as is the surrounding land, where there are plenty of walking trails.

—

8 Rangers Road, E4 7QH
020 7332 1911
www.visitessex.com
Daily 10:00–17:00; free
Chingford overland

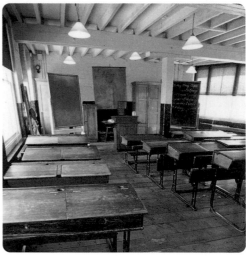

✤ RAGGED SCHOOL MUSEUM

SOCIAL HISTORY

When Thomas Barnardo arrived in London from Dublin, he couldn't quite believe the levels of poverty and destitution he found. Children would beg and sell scraps of food on the streets or wade knee-deep through the Thames mud, searching for things to sell. Education wasn't mandatory and big families relied on children to help top up incomes. Barnardo saw the need for, and founded, a missionary school where 'ragged children' could gain a basic free education. The school now functions as a museum, where visitors can sit in the old schoolrooms and try writing on slates.

A traditional East End kitchen from 1900 allows visitors to experience how hard it was to heat a home without electricity or light, and to see what it was like to have to take a tin bath in front of the fire to keep clean. This museum is popular with school groups during the week, while anyone is welcome to join Victorian lessons on the first Sunday of every month.

—

46–50 Copperfield Road, E3 4RR
020 8980 6405
www.raggedschoolmuseum.org.uk
Weds.–Thurs. 10:00–17:00 (Sunday school 14:00–17:00);
free
Bow Tube

✤ SUTTON HOUSE

SOCIAL HISTORY

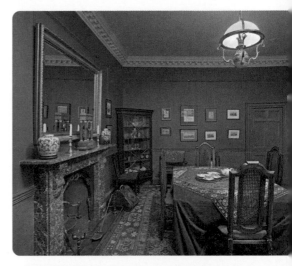

One thing you don't expect to see when you're walking through London's East End, is a Tudor manor house. Over the past 500 years, Sutton House has been several things, including a squat, a music venue and, during the Second World War, a centre for training fire wardens. Today, this impressively beautiful building is run and owned by the National Trust and is often full of local school children learning about the Tudor period (apt, since the house also operated as a school in the eighteenth century). A courtier of Henry VIII, Ralph Sadleir, built Sutton House in 1535. As you explore the oak-panelled rooms, keep your eyes peeled for ghosts – this place is described as one of the most haunted buildings in East London. In a novel twist, there's a room here called the Squatters' Room, recreated with the help of squatters who lived here in the 1980s. It makes a valuable comment on the ways in which different communities can shape the history of a neighbourhood.

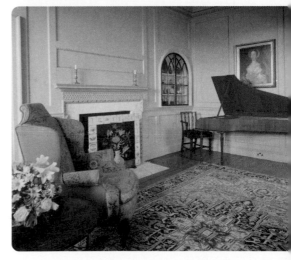

—

Homerton High Street, E9 6JQ

020 8986 2264

www.nationaltrust.org.uk/features/discover-sutton-house

Weds.–Fri. 15:00 (guided tour), Sat. 12:00–16:30; £

Hackney Central overland

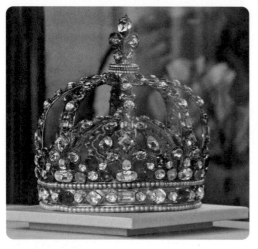
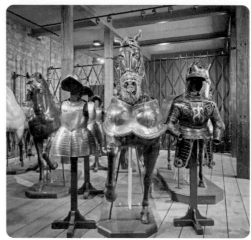

⚜ TOWER OF LONDON

CULTURAL HISTORY

For more than 600 years, the Tower of London was home to some of the world's most exotic creatures. Lions prowled the moat and a polar bear was tethered to a stump nearby. It started when the Holy Roman Emperor Frederick II gifted Henry III three leopards and so began London's first 'zoo'. The Tower of London remains remarkable to this day, simply because of its rich history. Princess Elizabeth I was imprisoned in the tower by her sister Mary, just metres away from where her mother Anne Boleyn lost her head on the chopping block. You can easily spend a full day here, especially during holidays, when there are lots of fun activities for kids (think dressing up and jousting). The Crown Jewels are on display, so you can glimpse the actual crown Queen Elizabeth II wore to her coronation. Expect to experience Tudor history and watch out for ghosts, especially Lady Jane Grey, who was beheaded here and allegedly haunts the Tower, screaming. Note that opening times vary from winter to summer.

—

Tower of London, EC3N 4AB
033 3320 6000
www.hrp.org.uk/tower-of-london
Tues.–Sat. 09:00-17:30, Sun.–Mon. 10:00-17:30
(Summer); Tues.–Sat. 09:00-16:30, Sun.–Mon.
10:00-16:30 (Winter); ££££
Tower Hill Tube

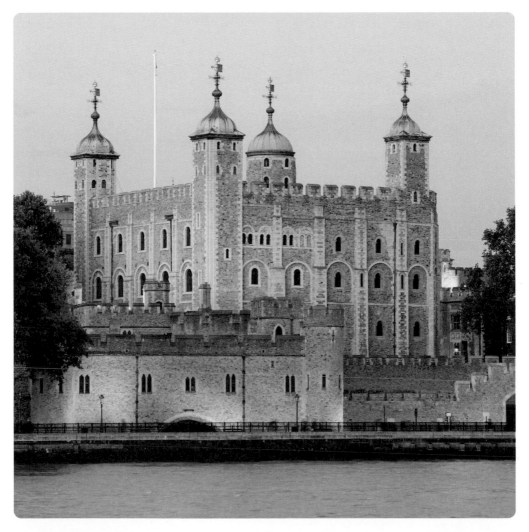

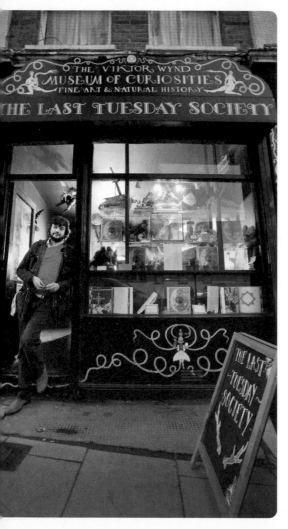

✤ THE VIKTOR WYND MUSEUM OF CURIOSITIES

CULTURAL HISTORY

OK, disclaimer. This is part absinthe-based cocktail bar and part museum, and the bar is just as much fun as the basement exhibition. It's the only museum of curiosities left in the City of London, and for that reason you should definitely head East to drink the green fairy and look at nineteenth-century stone masks. Come on a winter's day when the shop's gloom feels fabulously Victorian and restorative, and take the winding spiral stairs down into the basement. Staff will even let you take your drink down with you, so you can peruse the cabinets while trying their cocktails. Entry is for over-eighteens only, and as soon as you spot the etchings with sexy figures on them, the two-headed kittens and creepy skeletons, you'll understand why. The museum's goal is to 'steal visitors' time' and nothing else. You'll need a strong stomach to enjoy all the curiosities on display, but there's nothing that can't be put right by a few treats from the bar upstairs afterwards.

—

11 Mare Street, E8 4RP
020 7998 3617
www.thelasttuesdaysociety.org
Weds.–Sun. 12:00–23:00; £
Haggerston overland

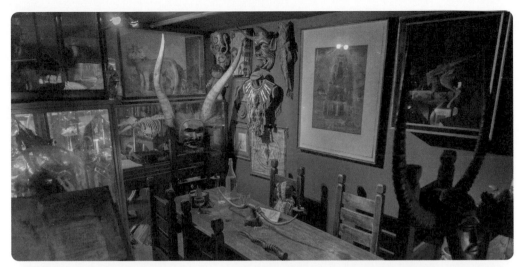

Walid Raad, 'Miraculous Beginnings' exhibition, 2010

✤ WHITECHAPEL GALLERY

CONTEMPORARY ART

If you're after exhibitions that challenge, head to Whitechapel Gallery. This is where Mark Rothko developed his exhibition template; Pop Art first came to the attention of the general public here; and the gallery's 'The New Generation' show of 1964 introduced the world to Bridget Riley, Patrick Caulfield and David Hockney. Whitechapel is tied up with activism, which isn't surprising if you consider its location. On the cusp of the City and Brick Lane, a culturally diverse neighbourhood, this is a location where two of London's different worlds collide. Past exhibitions have included a show by the Guerrilla Girls, an activist collective that challenges galleries to think harder about whether and why they display artworks by women. Another showcased the demise of LGBTQ venues around the capital, marrying social commentary and art.

—

77–82 Whitechapel High Street, E1 7QX
020 7522 7888
www.whitechapelgallery.org
Tues–Sun. 11:00–18:00 (Thurs. 11:00–21:00); free
Aldgate East Tube, Liverpool Street Tube & overland

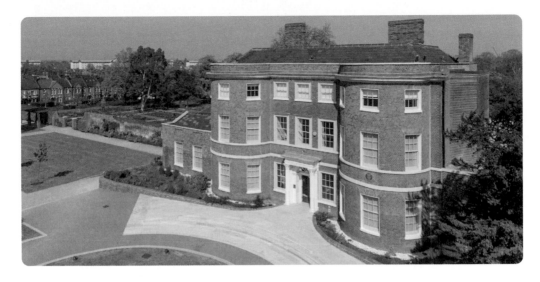

❖ WILLIAM MORRIS GALLERY
ARCHITECTURE/DESIGN

Craftsman, campaigner, designer – William Morris was a founding member of the Victorian Arts and Crafts movement, which rejected all things industrial and had a strong following during the chaotic and grimy late-Victorian era. This gallery is set inside William Morris's eighteenth-century childhood home. The only gallery in the world dedicated to Morris, it is crammed with work by his compadres, including statues, rugs and tiles by Dante Gabriel Rossetti, Ford Madox Brown and Edward Burne-Jones. On display are the first designs for some of Morris's famous wallpapers as well as artefacts from the designer's life, such as the satchel in which he carried socialist leaflets to demonstrations. Expect occasional displays of pieces right up to the present day, and from artists as varied as Grayson Perry (whose Walthamstow Tapestry was shown for a month) and May Morris. There's also a fine tea room serving delicious cake from local bakers.

Lloyd Park, Forest Road, E17 4PP
020 8496 4390
www.wmgallery.org.uk
Mon.–Sat. 10:00–17:00; free
Walthamstow Tube

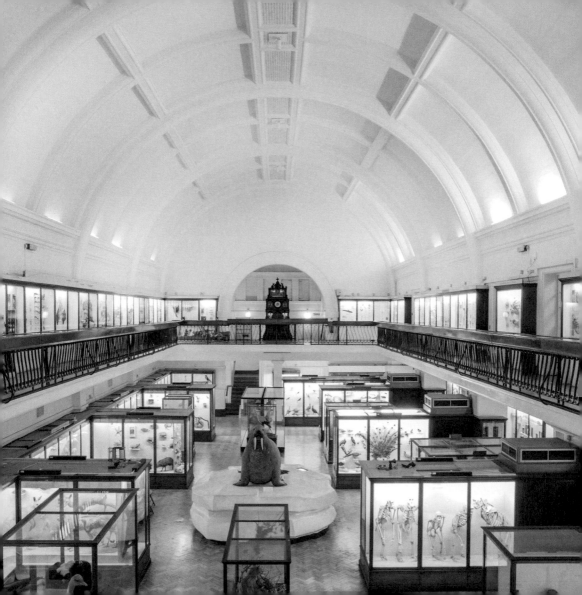

SOUTH-EAST LONDON

Horniman Museum

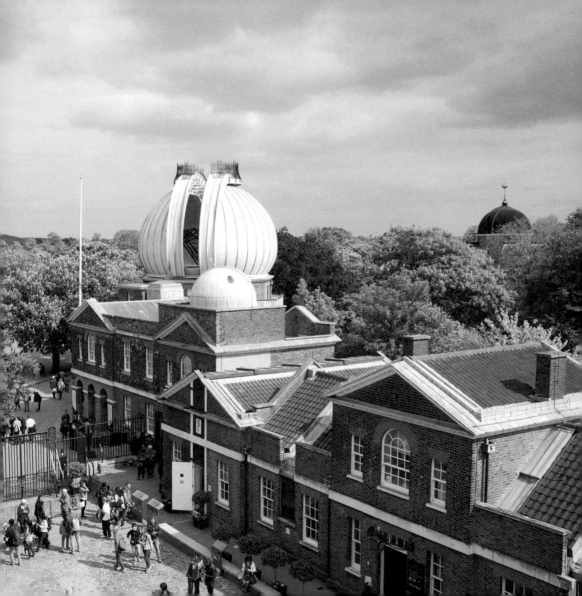

SOUTH-EAST LONDON

This district is home to one of London's oldest art museums, Dulwich Picture Gallery, as well as one of the city's leading contemporary galleries, White Cube. Venues on the fringes of Central London include Tate Modern and HMS *Belfast* by (and on) the river, and The Old Operating Theatre close to London Bridge – many locals maintain this last museum to be one of the best small museums in London. Further afield, the Horniman Museums and Gardens, Florence Nightingale Museum, Royal Observatory (opposite) and Imperial War Museum are perennially popular with kids. Less well known are the Brunel Museum, Garden Museum, Bethlem Museum of the Mind and Zandra Rhodes' colourful Fashion and Textile Museum, among others. With locations ranging from Bankside east to Greenwich and south to Forest Hill, be prepared to make the odd journey by bus and overland train as well as by Tube.

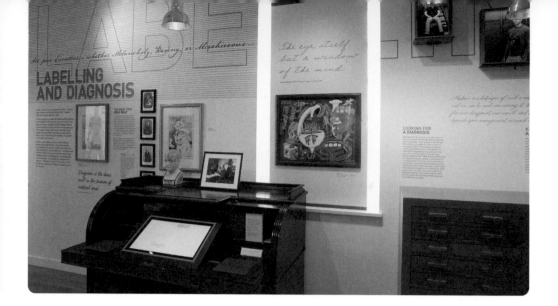

✤ BETHLEM MUSEUM OF THE MIND

HEALTH AND MEDICINE

Bethlem Museum of the Mind and its neighbouring gallery bring art and mental health together by displaying a collection of works created by both current and former patients. The museum also focuses on the Bethlem Royal Hospital, and how it has cared for its patients over time. Personal stories are centre stage, and include those from well-known patients that include artist Louis Wain. Mental health is a hot topic and the treatment of those with psychological conditions over the past couple of centuries frequently comes under scrutiny. The museum is honest about the limitations of mental health care. What's clear, however, is how much the people who run the Bethlem Royal Hospital care for patients today. The museum encourages you to grapple with ethical dilemmas, and asks you to stop and think about what you would do or say in certain situations, which makes it a stimulating and fascinating place to explore. The museum shop sells art painted by patients.

—

Monks Orchard Road, Beckenham, Kent BR3 3BX
020 3228 4227
museumofthemind.org.uk
Weds.–Fri. 10:00–17:00; free
Eden Park overland

✤ BRUNEL MUSEUM

SCIENCE AND TECHNOLOGY

Engineer Isambard Kingdom Brunel designed railways, ships, buildings and bridges, including the Clifton Suspension Bridge in Bristol. He also hosted the world's first underground concert. This museum in Rotherhithe celebrates his engineering work, but also plays host to choirs, concerts and theatre below ground. The grand entrance hall, designed by Brunel, is enormous – about half the size of Shakespeare's Globe. In winter, the Midnight Apothecary cocktail bar moves underground to a candlelit tunnel shaft, so visitors can explore Brunel's engineering legacy before supping a hot toddy below sea level. Keep an eye on the website for dates. There are regular talks about the great inventor, documenting the Thames tunnel he built, the engines he created, and the relentless drive of all who worked with him. The museum is in Rotherhithe, a flat walk a mile east of London Bridge on the Thames Path. One of the city's oldest pubs, The Mayflower, is nearby. A perfect Saturday afternoon.

—

Railway Avenue, SE16 4LF
020 7231 3840
www.brunel-museum.org.uk
Daily 10:00–17:00; £
Rotherhithe overland

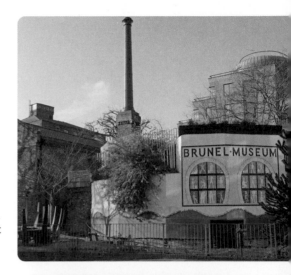

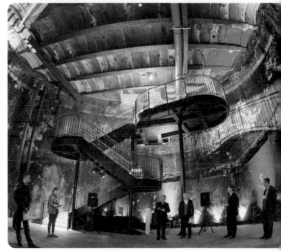

111

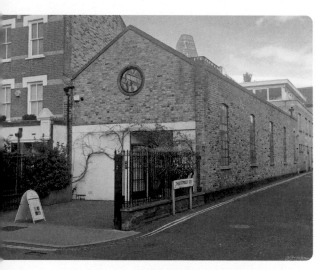

❖ THE CELLO FACTORY

<u>CONTEMPORARY ART</u>

Found in a Waterloo backstreet, The Cello Factory is a voluminous exhibition space drenched in natural light. Works are contemporary, with a strong mix of international and national, established and new artists. Jake & Dinos Chapman have exhibited here, as have Frank Bowling OBE RA and Gillian Ayres CBE RA. Interestingly, for a building that feels like a tardis when you step inside, it has some Whovian history of its own. At one time a strings factory, as the gallery name suggests (selling Stradivarius instruments), this is also the place in which the original daleks for *Dr Who* were built. The building has also served as a furniture repository for the Savoy Hotel. The curator clearly makes good use of the space, with large sculptures accompanying paintings, and displays that drift their way down from the high, beamed ceilings.

—

33–34 Cornwall Road, SE1 8TJ
www.thecellofactory.com
Opening times vary, see website for details; free
Waterloo Tube & overland

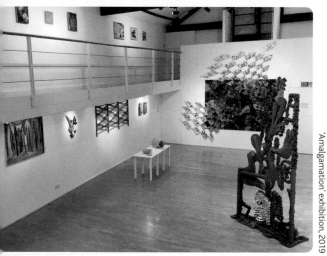

'Amalgamation' exhibition, 2019

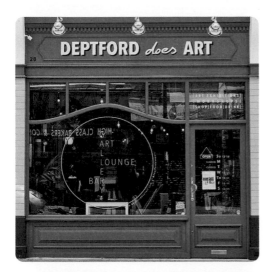

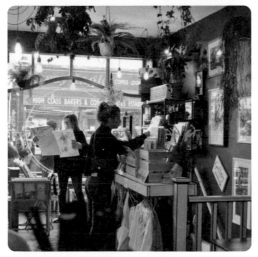

✤ DEPTFORD DOES ART

CONTEMPORARY ART

Deptford Does Art is a three-in-one gallery-cafe-bar. It dishes up some of the best flat whites in South-east London and the space also sells prints, clothing and small 'bits'. It's a calm oasis once you've escaped the bustling Deptford High Street, and sells excellent vegan food, too. The space was founded as a part-time pop-up by Zuzana Greenham, who originally worked in a nearby pub. Since then, it has blossomed, with a basement gallery, vegan cafe and unframed prints. It also hosts the South London Zine festival which takes place every August. There are zines for sale and on display, as well as workshops so visitors can have a go at their own illustrations. Being a bar and a gallery, it's open late, so if you're in Deptford you can grab a dose of culture and a cocktail at the same time.

28 Deptford High Street, SE8 4AF
www.deptforddoesart.com
Weds.–Sat. 10:00–18:00, Sun: 10:00–17:00; free
Deptford High Street overland

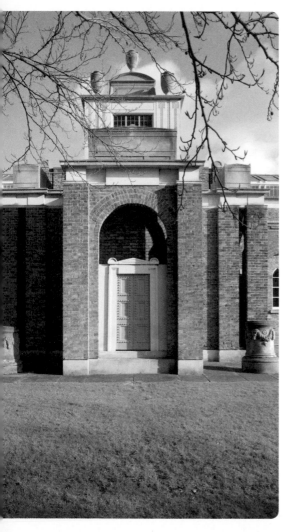

✤ DULWICH PICTURE GALLERY
FINE ART

Located in the bucolic surroundings of Dulwich Village, the Dulwich Picture Gallery was the first museum to bring art to the masses when it opened in 1817. It plays host to one of the country's most impressive collections of Old Masters, which includes pieces by Adriaen van de Velde, Raphael and Jan Vermeer. A number of the founding paintings were previously on display in Dulwich College, a public boys' school a few hundred metres away. Dulwich frequently curates exhibitions of modern British artists. 'Cutting Edge: Modern British Printmaking' showcased works by Cyril Power and Paul Nash, while Vanessa Bell and Eric Ravilious have both had extensive exhibitions here. According to the *Guinness Book of Records*, Dulwich Picture Gallery is home to the world's most stolen painting, Rembrandt's *Portrait of Jacob de Gheyn III*, which has been stolen four times. On one occasion, it turned up under a bench in Streatham, on another it was found in a left-luggage office in Germany.

—

Gallery Road, SE21 7AD
020 8693 5254
www.dulwichpicturegallery.org.uk
Tues.–Sun. 10:00–17:00; £££
West Dulwich overland

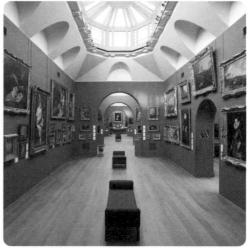

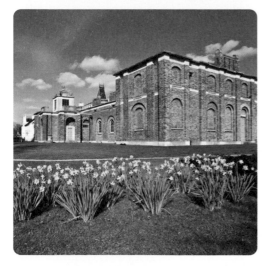

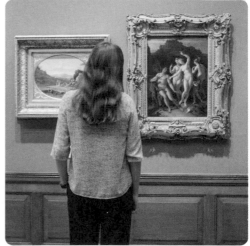

✣ FASHION AND TEXTILE MUSEUM
<u>CULTURAL HISTORY</u>

That fashion designer Zandra Rhodes has a penthouse apartment on the top of this big, bold museum tells you everything you need to know about the calibre of the place. Rhodes founded the museum in 2003 and the building's sunflower-yellow walls, designed by Mexican architect Ricardo Legorreta, punch colour into the neighbourhood. There is no permanent collection, but exhibitions may include dress designs, or vibrant textiles or the swinging sixties. This is a small museum, and it won't take long to see the exhibition. However, it has another role as a place to inspire new creatives. The educational arm is operated by Newham College, so there are plenty of workshops and talks running through the year. Festive pom-poms, Photoshop for fashion and textiles, silk-painting and pattern-cutting are among the workshops on offer. There's no cafe on site, but ticket-holders get a ten per cent discount in the cafe across the road.

83 Bermondsey Street, SE1 3XF
020 7407 8664
www.ftmlondon.org
Tues.–Sat. 11:00–18:00 (Thurs. 11:00–20:00),
Sun. 11:00–17:00: £
London Bridge Tube & overland

✤ FLORENCE NIGHTINGALE MUSEUM

HEALTH AND MEDICINE

Almost every schoolchild has learned about Florence Nightingale – also known as the lady with the lamp – and how she travelled to a war zone nearly 3,200km (2,000 miles) away to nurse sick soldiers, at a time when women didn't have the vote and were discouraged from working. Located within St Thomas' hospital in Waterloo, this museum offers an insight into the conditions nurses had to deal with before anaesthesia, and explores Nightingale's life and legacy. The museum is small, but packed with information, which includes a 'talk' given by Nightingale herself.

The museum reveals how Nightingale was often disliked by her peers, but hugely admired by the men she tended. Other exhibits focus on nursing history – for example, there is a section on nursing during the Spanish Flu pandemic that struck the world just as the First World War ended in 1918. It demonstrates the work nurses did, and even has beds set up to show what hospital wards would have looked like at the time.

—

2 Lambeth Palace Road, SE1 7EW
020 7188 4400
www.florence-nightingale.co.uk
Daily 10.00–17.00; £
Waterloo Tube & overland

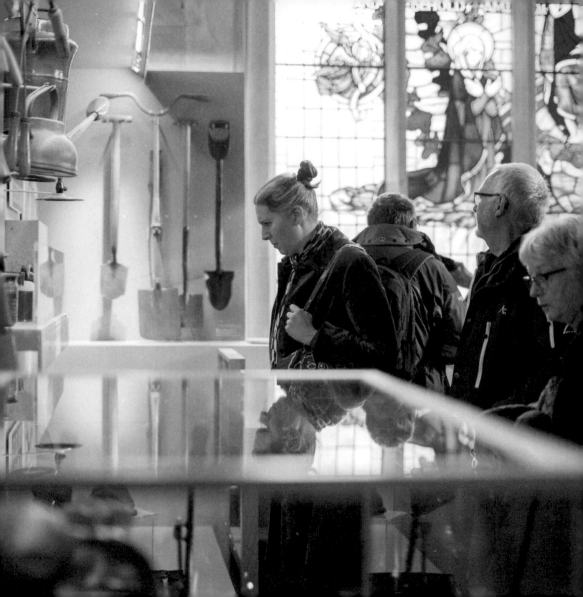

✤ GARDEN MUSEUM

<u>NATURAL HISTORY</u>

This quirky museum celebrating all things flora is tucked away behind Lambeth Palace. Don't expect to see any actual plants, other than those in a pretty courtyard garden, but come to learn about the history of gardening, to read the diaries of head gardeners who have managed large stately homes, and to take at look at some of the traditional tools and techniques used for keeping slugs and garden mites at bay. Visitors can join an interactive electronic game in which they try to gather plants from Africa, Asia and the Americas. The museum is housed in the beautiful old church of St Mary's on the banks of the River Thames; admission includes entry to its flint-studded tower, with amazing views of Westminster and Lambeth Palace. The churchyard is the burial place of the original planthunter John Tradescant (c. 1570s–1638). The museum sometimes runs lates, which host talks, workshops and a chance to spend a peaceful evening in one of the most beautiful structures on the South Bank.

—

5 Lambeth Palace Road, SE1 7LB
020 7401 8865
www.gardenmuseum.org.uk
Daily 10:30–17:00; £
Lambeth North Tube

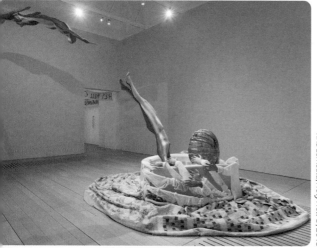

Kris Lemsalu, *Holy Hell O*, 2018

✤ GOLDSMITHS CENTRE FOR CONTEMPORARY ART

CONTEMPORARY ART

Home to the renegades who'd rather study south of the river than in stuffy Chelsea, Goldsmiths has a reputation for pushing the boundaries. Alumni include Lucian Freud, Antony Gormley, Damien Hirst, Sarah Lucas and Bridget Riley. The gallery is located in the renovated Victorian Laurie Grove Baths, which closed to the public in 1991. In 1999, the swimming pools were repurposed as artist studios, and in 2018, the pump rooms and roof space became the gallery. Designed by Turner Prize winning collective Assemble, the building itself is art. Polished concrete and industrial dark walls are the perfect backdrop for canvases and immersive videos. Students' galleries adjoin the main space – so be sure to take a peek at work being produced by blockbuster artists of the future.

St James', SE14 6AD

020 8228 5969

www.goldsmithscca.art

Weds.–Sun. 11:00–18:00 (Thurs. 11:00–21:00); free

New Cross overland

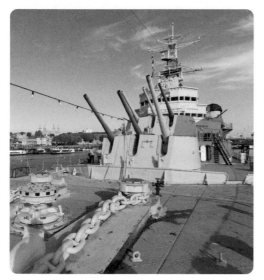
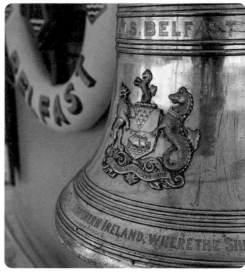

✤ HMS *BELFAST*

<u>MILITARY HISTORY</u>

Who doesn't want to scurry down a near-vertical ship's ladder, peep out of portholes and see how food is cooked on the high seas? Moored in the centre of the River Thames near London Bridge, HMS *Belfast* is a Second World War warship. With nine decks to explore, head deep into the bowls of the ship 4.5m (15ft) below sea level or stay on deck to feel the wind in your hair. Check out the guns that fired some of the first shots on D-Day and hear stories from those who worked onboard. HMS *Belfast* saw active service at the height of

the war. In 1939 she struck a mine, and following extensive repairs, began to escort Arctic convoys towards Soviet Russia. She helped to destroy German vessel SMS *Scharnhorst*, and when you're on the bridge turning the wheel, it's easy to imagine the stressful situations that played out up here. When you've finished hoiking up and down the decks, there's an onboard ship's cafe to relax in. Thankfully, weevils and spam are not included.

—

The Queen's Walk, SE1 2JH
www.iwm.org.uk/visits/hms-belfast
Daily 10:00–17:00; £££
London Bridge Tube & overland

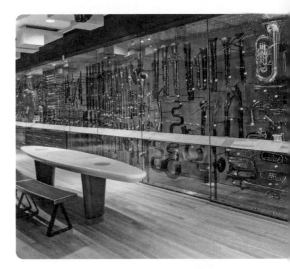

✤ HORNIMAN MUSEUMS AND GARDENS

NATURAL HISTORY

Every city needs a museum full of taxidermy with charts illustrating evolution from the Ice Age to the present day. The Horniman offers all this and more. The centrepiece of the museum, which is in deepest South-east London (Forest Hill), is an enormous stuffed walrus, but there's also a sprawling rockpool showing different ecosystems and sealife. The walrus is known as the overstuffed walrus because the Victorian taxidermists didn't realise the animal had lots of folds of skin and just packed in as much filling as they could. There are so many great things for kids to touch here, and ways for them to let off steam in the expansive Horniman Gardens that surround the main building. The Horniman is just on the edge of one of London's long-distance walks, the Green Chain, so if you want to extend your stomping-in-puddles time, this is a great place to start.

100 London Road, SE23 3PQ
020 8699 1872
www.horniman.ac.uk
Daily 10:00–17:30; free
Forest Hill overland

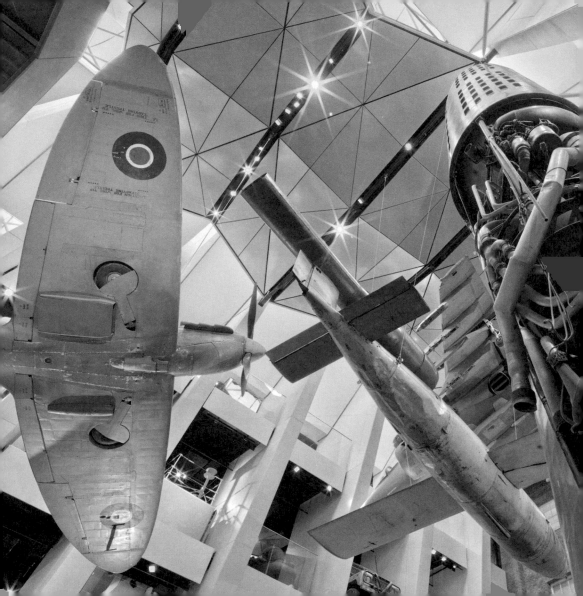

♣ IMPERIAL WAR MUSEUM

MILITARY HISTORY

The Imperial War Museum was founded in 1917, before the First World War even ended. The aim was to highlight the achievements of the military and to document human sacrifice in the face of war. Showcasing conflicts that Britain and its Commonwealth countries have been involved in through the twentieth and twenty-first centuries, this is one of London's richest and most stimulating spaces. Fighter planes soar overhead as you enter and you can experience what it was like to be a soldier in the trenches as you walk through an interactive exhibition. Hear the bombs explode, listen to the rat-tat-tat of guns, and hear original soldier testimonies on the agonies of suffering from trench foot. The Holocaust museum offers two floors of compelling exhibits that detail Hitler's rise to power. Beautifully curated, temporary exhibits have covered topics as diverse as 'Rebel Sounds', on the ways in which music can support revolt, to an in-depth look at Yemen's war told through photographs and human stories.

———

Lambeth Road, SE1 6HZ
020 7416 5000
www.iwm.org.uk
Daily 10:00–18:00; free
Lambeth North Tube

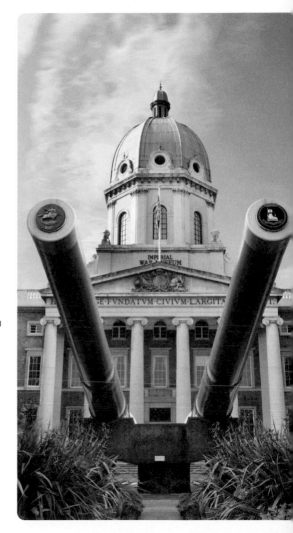

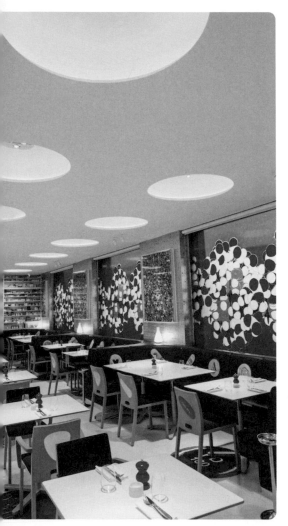

❖ NEWPORT STREET GALLERY

CONTEMPORARY ART

From the windows of the train that travels from Vauxhall to Waterloo, passengers can make out the jagged roof of Newport Street Gallery, Damien Hirst's personal art space. It's in an obscure-ish location, by the railway arches in the backstreets of Vauxhall. By all means, come for the art, but don't miss the building's architectural merits. A series of renovated workshops that used to hold costumes for London's theatres, it was upcycled by the same architects who developed Tate Modern (see pages 130–131), Caruso St John. The wooden stairs plunge through ovals of white, presenting the perfect frame for a selection of Hirst's personal, 3,000-strong art collection (amassed over the last four decades). It includes works by Pablo Picasso, Francis Bacon, Sarah Lucas and Jeff Koons. Exhibitions often include works from other collections and by emerging artists. There's a cafe that has (probably) the funkiest bar in the whole of London, with marble inlay flooring and glass windows depicting strands of DNA.

———

1 Newport Street, SE11 6AJ

www.newportstreetgallery.com

Opening times vary, check website for details; free
Vauxhall Tube

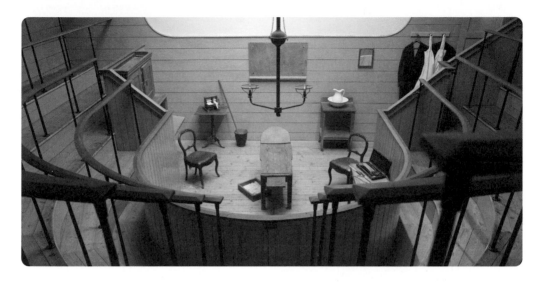

✤ THE OLD OPERATING THEATRE

HEALTH AND MEDICINE

Up narrow, wooden stairs just by London Bridge, The Old Operating Theatre used to be part of Guy's Hospital. This is where medical students learned how to chop, splice and dissect corpses. There's a gory cabinet full of terrifying-looking saws for amputating limbs, and a gynaecological section featuring a wince-worthy display of metal instruments. The tiny museum is brimming with interesting information. Did you know, for example, that water in which snails are boiled alive could be used for treating venereal diseases? Or that the sawdust collecting blood beneath the operating table was often so congealed that it needed a cement cutter to get through it? This little museum is especially delightful for being in its original location. Allow the creaky floorboards to transport you back to the nineteenth century. Up in the herb garret stuffed with dried herbs and kidneys in glass jars, it wouldn't be surprising if a random patient suddenly appeared.

—

9a St Thomas Street, SE1 9RY
020 7188 2679
www.oldoperatingtheatre.com
Mon. 14:00–17:00, Tues.–Fri. 10:30–17:00, Sat.–Sun. 12:00–16:00; £
London Bridge Tube & overland

✤ ROYAL OBSERVATORY

SCIENCE AND TECHNOLOGY

The Royal Observatory sits on the crest of Greenwich Park, overlooking the River Thames and the historic town centre below. It's cleaved in two by the Prime Meridian Line where east meets west (this is how Greenwich Mean Time got its name) and the telescope here is still used occasionally. The observatory's main operations have ceased, owing to light pollution, and today it functions mostly as a museum. Charles II commissioned Sir Christopher Wren to design the Royal Observatory in 1675 and the building remains a stunning example of seventeenth-century architecture. The museum hosts a collection of some of the world's most impressive clocks, including examples used by mariners and the Fedchenko clock, the world's most accurate mass-produced timepiece. There is also a planetarium here, where you can experience flying to the heart of the sun and an exploration of our solar system.

—

Blackheath Avenue, SE10 8XJ
020 8312 6565
www.rmg.co.uk
Daily 10:00–17:00; ££
Cutty Sark or Greenwich DLR

✤ SOUTH LONDON GALLERY

MODERN/CONTEMPORARY ART

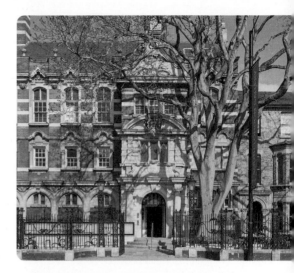

Tucked away on busy Peckham Road, which stretches between Camberwell and Peckham, South London Gallery is one of London's older art institutions. Founded in 1891, it's had ties to Camberwell College of Art for much of the twentieth century, and has long supported cutting-edge artistic practice. The gallery has an exceptional collection of twentieth-century prints by artists that include John Piper and Christopher Wood. A champion of the Young British Artists (YBA) in the 1990s, the gallery has hosted exhibitions by Tracey Emin on several occasions, and owns works by Antony Gormley and Sarah Lucas. Today's focus is on British and international emerging artists, who have not yet had their own shows. This is the place to come if you want to keep your finger on London's artistic pulse. The gallery also runs a residency programme for artists. For hungry patrons, Crane's Kitchen, the onsite cafe, does an outstanding brunch as well as steaming cups of strong coffee to fortify the mind after a stimulating show.

65 Peckham Road, SE5 8UH
020 7703 6120
www.southlondongallery.org
Tues.–Sun. 11:00–18:00 (Weds. 11:00–21:00); free
Denmark Hill Tube

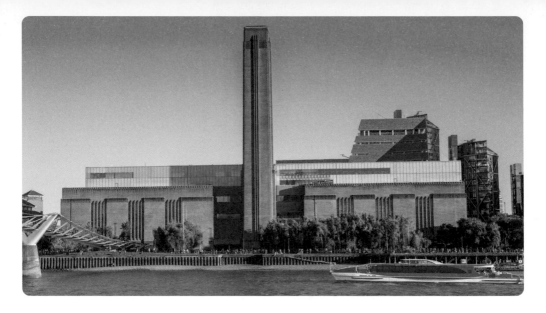

❖ TATE MODERN

The Turbine Hall within the former power station on the south bank of the River Thames has to be one of the most spectacular exhibition spaces in the city. Measuring 35m (115ft) tall and 155m (510ft) long, it is used for exhibiting large-scale and interactive works. Famously, it has been home to *Shibboleth*, where Colombian artist Doris Salcedo cracked open the floor of the room, and Louise Bourgeois's *I Do, I Undo and I Redo* – three steel climbing towers. Works in Tate Modern's permanent collection include Pablo Picasso's *Nude Woman with Necklace* and *Mountain Lake* by Salvador Dalí. Revolving exhibitions have featured Georgia O'Keeffe, Bridget Riley and Natalia Goncharova. The Blavatnik Building – a new extension designed by architects Herzog & de Meuron – opened in 2016, creating sixty per cent more exhibition space for the gallery and crammed with cutting-edge new works by boundary-pushing artists.

Bankside, SE1 9TG
020 7887 8888
www.tate.org.uk
Daily 10:00–18:00 (Fri.–Sat. 10:00–22:00);
free (prices for select exhibitions vary)
Blackfriars Tube

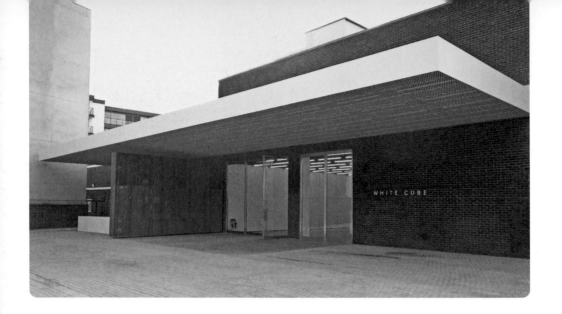

✤ WHITE CUBE

CONTEMPORARY ART

When White Cube Bermondsey launched in 2012, it fast became Europe's biggest-ever commercial art gallery. It's vast, at 5,400 sq m (58,000 sq ft), and is housed in a former 1970s warehouse on fashionable Bermondsey Street. The gallery feels sterile, and that's one of its best qualities in a way – although the space is an Instagrammer's haunt, it's so large that you won't be bothered by poseurs. Founded by Jay Jopling, originally in Hoxton, White Cube was among the first places to support the Young British Artists (YBAs) during the 1990s.

Shows tend to feature big installation pieces. Damien Hirst is a regular contributor to the vast space, while other artists, such as Dora Maurer and Mona Hatoum – whose work uses concrete, human hair and glass to address the contemporary political situation – have also had work exhibited at White Cube.

—

144–152 Bermondsey Street, SE1 3TQ
020 7930 5373
www.whitecube.com
Tues.–Sat. 10:00–18:00, Sun. 12:00–18:00; free
London Bridge Tube & overland

Anselm Kiefer, Superstrings, Runes, The Norns, Gordian Knot, 2020

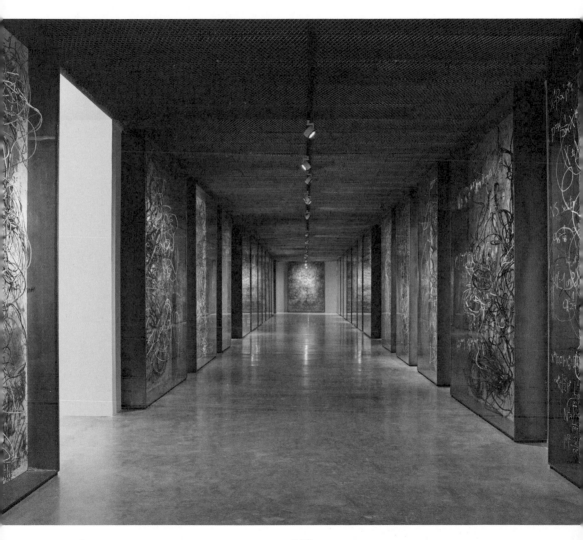

HAVE YOUR RACKET RESTRUNG HERE
BY "BOW BRAND"
THE WORLD'S LEADING TENNIS STRINGS
1927 SUCCESSES INCLUDED
DAVIS CUP·BRISTOL CUP
ALL ENGLAND PLATE
CHAMPIONSHIPS OF
THE WORLD·AMERICA·FRANCE
AUSTRALIA·EGYPT·SWITZERLAND
ALL WITH "BOW BRAND" CHAMPIONSHIP STRINGS

SOUTH-WEST LONDON

Wimbledon Lawn Tennis Museum

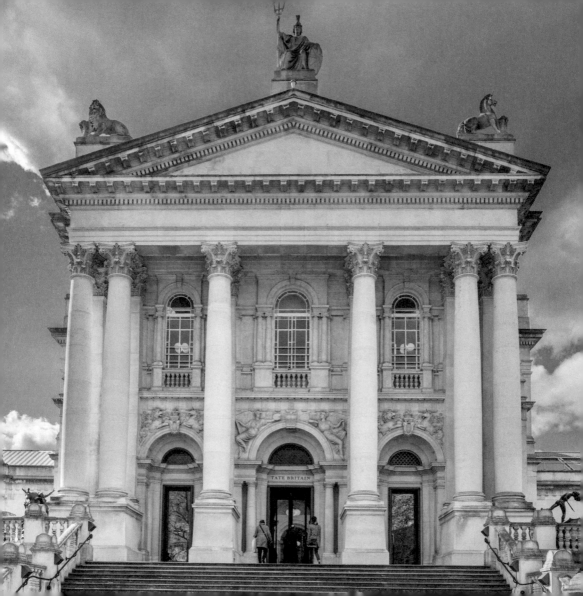

SOUTH-WEST LONDON

Take a dip south-west of Central London for a handful of family-friendly museums and galleries that include Wimbledon's Lawn Tennis Museum and Windmill Museum, and Brixton's Black Cultural Archives and the botanical Archives Collection at Kew. Many of the venues lie in close proximity to green spaces for exploring afterwards, from Crystal Palace's woodland walks to the wildness of Richmond Park. Bear in mind that much of the South-west is poorly served by the Tube, although several buses and overland trains will get you from A to B. Why not take advantage of Tate Britain's riverboat link with Tate Modern to explore venues in South-west and South-east London in one day?

❖ THE ARCHIVES COLLECTION, KEW

NATURAL HISTORY/SOCIAL HISTORY

The Archives Collection is a treasure trove of documents and objects relating to 1,000 years of British history. The official records of the Royal Botanic Gardens, Kew, are kept here, and include Charles Darwin's letters from his travels on HMS *Beagle*, as well as personal papers from other botanists and gardeners including Joseph Hooker and Marianne North. If you want to dig deep into the archives you might need to book ahead, but otherwise it's free to check out the exhibitions and journals on display. Photographs of the female gardeners in the late nineteenth century show them in bloomers and woollen stockings: practical wear to stop the women from 'sweethearting' with the men. All told there are more than seven million documents in storage here, from works on rare plants to maps and records of species.

—

Royal Botanic Gardens, Kew, Surrey, TW9 3AE
020 8332 5414
www.kew.org/science/collections-and-resources/
collections/library
Mon.–Fri. 10:00–16:00; free
Kew Gardens Tube

✤ BLACK CULTURAL ARCHIVES

CULTURAL HISTORY

The Black Cultural Archives is the UK's only museum dedicated to the history and preservation of African and Caribbean heritage. Located in the heart of Brixton, home to many Windrush families since the 1950s, this shiny new building showcases books, photographs and testimonies galore. The museum's goal is to share untold stories, and to inform visitors about the vital ways in which people of African and Caribbean descent have contributed to British life. The museum doesn't shy away from exploring racist trends: there are plenty of references to campaigning against racial inequalities in the United Kingdom. The museum's first exhibition invited visitors to reimagine the black woman in Britain, asking them to look further and deeper into history to reveal hidden truths. More recent exhibitions have focused on the lives of black people in Georgian England and, in collaboration with the V&A (see pages 166–167), the archives possess significant photographs and sources on black history.

—

Windrush Square, SW2 1EF
020 3757 8500
www.blackculturalarchives.org
Tues.–Sat. 10:00–18:00; free
Brixton Tube

140

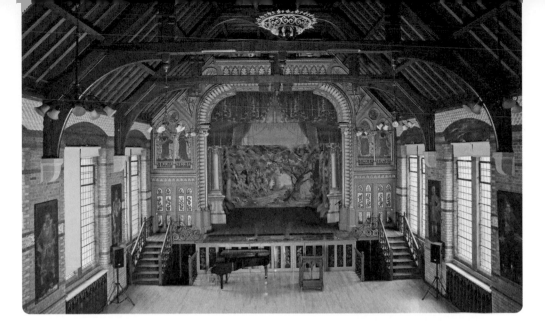

❖ LANGDON DOWN MUSEUM OF LEARNING DISABILITY

In the nineteenth century, people born with disabilities were often treated as freaks or sectioned in abominable conditions. In an attempt to address this, Dr Langdon Down introduced a more enlightened view, helping those with learning disabilities to live more normal lives. He worked as a medical superintendent at the Royal Earlswood Asylum, and paraphernalia from his work is on display at the Langdon Down Museum of Learning Disability. The museum also showcases the life and work of James Henry Pullen, an inmate of the asylum who was a genius inventor and model maker. It's well worth a trip to Teddington to understand the history of disability a little better. The museum is open to the public around once a month, so check the website for information. And while you are here, drop in to the traditional, Victorian-era, Normansfield Theatre for a fanciful step back in time.

—

2A Langdon Park, Teddington, Middlesex, TW11 9PS
0333 1212 300
www.langdondownmuseum.org.uk
Free
Hampton Wick overland

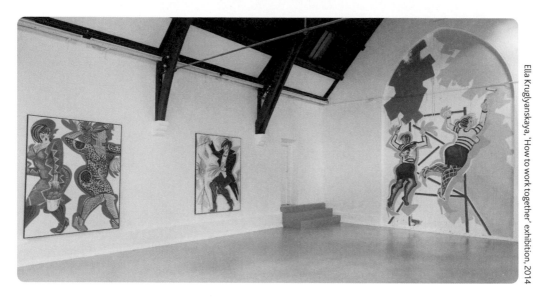

Ella Kruglyanskaya, 'How to work together' exhibition, 2014

❖ STUDIO VOLTAIRE

CONTEMPORARY ART

London rents are so high, it can seem impossible for any new art movement to emerge and seed. This is where artists' collectives and cooperatives come in – organisations where the onus isn't on one person to maintain a property, get people in to see shows and secure sales, but on a number of people. Studio Voltaire champions under-represented and emerging artists, running studios and a non-profit gallery in Clapham. Describing itself as 'agenda-setting', it can certainly feel as if Studio Voltaire is one of the last places in the capital to be producing raw and powerful societally relevant art. The studio invests in artists who struggle to gain exposure in commercial spaces. The gallery, in a former church hall with a wonderful vaulted ceiling, is free to visit, and gives visitors the opportunity to see not just brand-new work, but work from artists who may have been underrepresented throughout their careers.

1A Nelsons Row, SW4 7JR
020 7622 1294
www.studiovoltaire.org
Weds.–Sat. 10:00–18:00; free
Clapham Common Tube

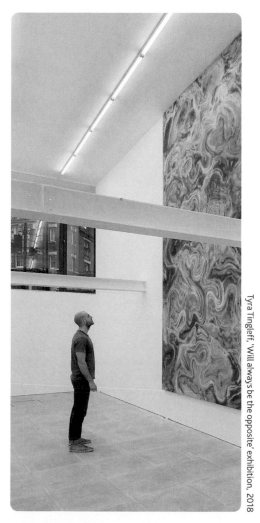

Tyra Tingleff, 'Will always be the opposite' exhibition, 2018

✣ THE SUNDAY PAINTER

CONTEMPORARY ART

Harry Beer, Tom Cole and Will Jarvis founded this small gallery in South London's Vauxhall area. The unusual name has roots in the trio's art school days when, on pushing back on having to write a dissertation, their tutor described them as Sunday painters – hobbyists. They embraced the name and it stuck. The gallery was originally located in a disused pub function room in Peckham, with the team running studios alongside the gallery to help cover costs. When they moved to their current home in 2017, one of the units in the new premises housed an off-license and another a chicken shop. The Sunday Painter has since taken over, making this space its own. It's not quite as sleek as those in Mayfair and Marylebone, but it's all the more pleasurable for that, and the quality of work shown is just as high. Their goal is to display art that evolves with the world around it, art that remains relevant. The Sunday Painter represents and exhibits the work of Leo Fitzmaurice, Rob Chavasse, Piotr Łakomy and Samara Scott.

——

117–119 South Lambeth Road, SW8 1XA
07811 138 350 (Harry Beer)
www.thesundaypainter.co.uk
Weds.–Sat. 12:00–18:00; free
Oval Tube

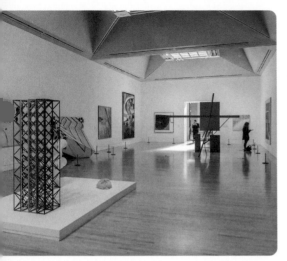

❖ TATE BRITAIN

FINE/CONTEMPORARY ART

Tate Britain focuses on British art from 1540 to the present day. A renovation in 2013, by Caruso St John Architects, opened the building into a spacious, light and welcoming gallery. A walk through 'British Art' takes visitors from the start of the collection – *The Cholmondeley Ladies* and regal-looking pieces that include Hubert Le Sueur's *Charles I* bust – to works by Stanley Spencer and the Kitchen Sink artists. Expect to see pieces by C.R.W. Nevinson, David Bomberg and Francis Bacon's *Three Studies for Figures at the Base of a Crucifixion* on the way. Tate Britain is also home to some of the capital's most beautifully curated exhibitions. Past shows have included a retrospective of pioneering photographer Don McCullin and the revolutionary 'Queer British Art' display, in recognition of works long hidden from view. Learn more about the exhibitions with free fifteen-minute public talks (Tues.–Thurs. 13:15). A boat runs between the Tate Modern and Tate Britain so you can combine your arty sightseeing with a scenic boat tour.

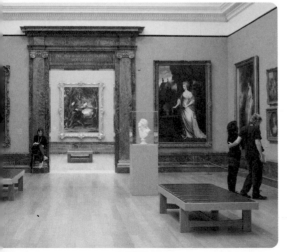

Millbank, SW1P 4RG
020 7887 8888
www.tate.org.uk
Daily 10:00–18:00 (Fri.–Sat. 10:00–22:00); free (prices for select exhibitions vary)
Pimlico Tube

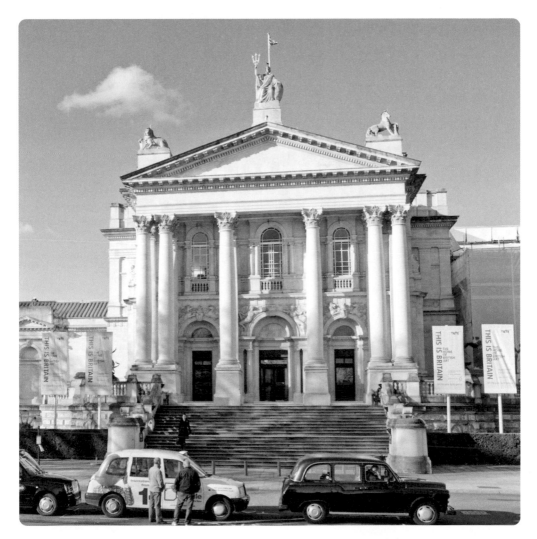

✤ WIMBLEDON LAWN TENNIS MUSEUM

CULTURAL HISTORY

Tennis fans, this one's for you. It's the largest tennis museum in the world, packed with interactive exhibits offering glimpses into every aspect of the world-famous lawn tennis tournament. There's no shortage of facts to keep you entertained – did you know, for example that 10,000 litres (17,500 pints) of cream are consumed during Wimbledon? Or that the fastest serve ever recorded at Wimbledon was 148 kmh (92 mph) by Taylor Dent in 2010? Tennis paraphernalia abounds, including what could be the world's oldest tennis racquet dating back to 1558 and the Wimbledon trophies held aloft at the end of a tournament. Exhibits are not confined to glass-cased artefacts either: visitors get the chance to sit in the umpire's chair and, using VR technology, they also have a chance to head back in time to see what tennis at Wimbledon used to be like. There's even a full 360-degree show on offer, using virtual-reality technology. A visit to central court is included in the price so you, too, can pretend you're walking out to fans' adoring cheers.

—

Church Road, SW19 5AE
020 8946 6131
www.wimbledon.com/en_GB/museum_and_tours
Daily 10:00–17:00; ££££
Wimbledon, Southfields overland

✤ WIMBLEDON WINDMILL MUSEUM

<u>SOCIAL HISTORY</u>

It might come as a surprise when you stumble across this windmill slap bang in the centre of Wimbledon Common. In 1816, a carpenter applied to build a windmill on common land and it was erected the following year. However, in 1864 the mill ground to a halt as a business venture, and was refashioned as accommodation. The mill is in a prominent location on the common; during the Second World War, one of its sails was removed and it was camouflaged green to reduce visibility from the air. Today, you can visit at weekends and over bank holidays. The museum opened in 1976 when the rest of the windmill was still being used as accommodation for rangers who patrolled the common. Now, the museum stretches across multiple floors, showing how grain used to be ground and how English mills work. It's a quirky, one-off museum, perfect for a cultural pitstop after a day stomping across the common.

—

Windmill Road, SW19 5NR
www.wimbledonwindmill.org.uk/museum
Sat. 14:00–17:00, Sun. 11:00–17:00; free
Wimbledon Tube and overland

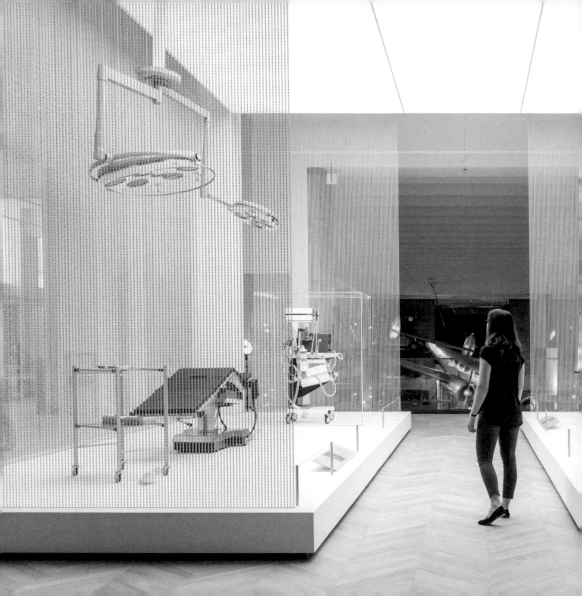

WEST LONDON

Dental technology at the Science Museum

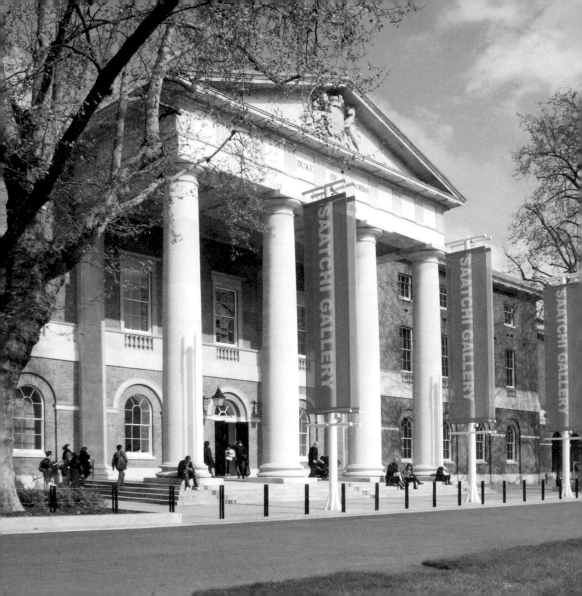

WEST LONDON

White stuccoed houses, stretches of green parks and streets named
after past inhabitants' country estates – West London is markedly different
from the rest of the city. This sedate area is home to what's casually known as
the museum mile, which features such world-class big hitters as the Science
Museum, with its hands-on, child-friendly exhibitions, and the Victoria and
Albert Museum, best known for its blockbuster shows and collections of
artefacts from around the world. These popular hotspots
are incredibly busy on Saturdays and during school holidays – aim to
get there first thing in the morning if you can't visit during the week.
For a quieter life altogether, take your pick from a host of charming
venues that include Leighton House Museum, the Polish Institute
and Sikorski Museum and the Saatchi Gallery (opposite).

✤ BEN URI GALLERY AND MUSEUM

MODERN/CONTEMPORARY ART

Russian émigré Lazar Berson set up this little gallery in 1915, with a view to supporting craftspeople and artists who couldn't get a foothold in the traditional art world. The gallery became known as the 'art museum for everyone'. The deceptively large collection features works from those who have fled their home countries for a variety of reasons. It boasts as many as 1,300 pieces, from 400 artists, from 40 countries. Among the names are Mark Gertler, Jacob Epstein, Franz Auerbach, Sonia Delaunay and Chaim Soutine. Temporary exhibitions have included 'Refugees – The Lives of Others', which explored ways in which German refugees gave back to the UK artistically. The gallery has hosted similar exhibitions highlighting the work of Polish artists. Until Ben Uri receives more funding, this small gallery can only exhibit a limited number of works at any one time, so be advised you might not get to see all the artists you'd like when you visit.

—

108A Boundary Road, NW8 0RH

www.benuri.org.uk/collection

Mon.–Fri. 10:00–17:00 (Weds. 10:00–20:00); free

(£ on some exhibitions)

St John's Wood Tube

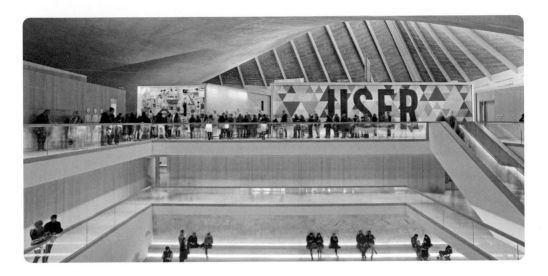

✤ DESIGN MUSEUM

ARCHITECTURE/DESIGN

A soaring parabolic roof set amid the greenery of London's Holland Park, the Design Museum is a paean to functional design, from cars to Bauhaus to cutlery. The building used to be the Commonwealth Institute but was redeveloped by architects Arup, OMA and Allies and Morrison to include an oak-and-marble-lined atrium with a Scandi vibe. The result is a big, light space, with plenty of room for a snaking exhibition that runs around its edges. The permanent exhibition includes sewing machines, London Underground designs and the evolution of the mobile phone.

Temporary exhibitions are often spectacular and geared towards true enthusiasts: there has been a show dedicated to Ferrari; another on Stanley Kubrick's work. Worth marking in the calendar is Beazley Designs of the Year, which showcases futuristic urban design, transport design and gadgets. If you're coming to see the permanent exhibition, you'll be able to visit in an hour. Note that this is not a gallery for young children.

—

224–238 Kensington High Street, W8 6AG
020 3862 5900
www.designmuseum.org
Daily 10:00–18:00; free (££ on some exhibitions)
High Street Kensington Tube

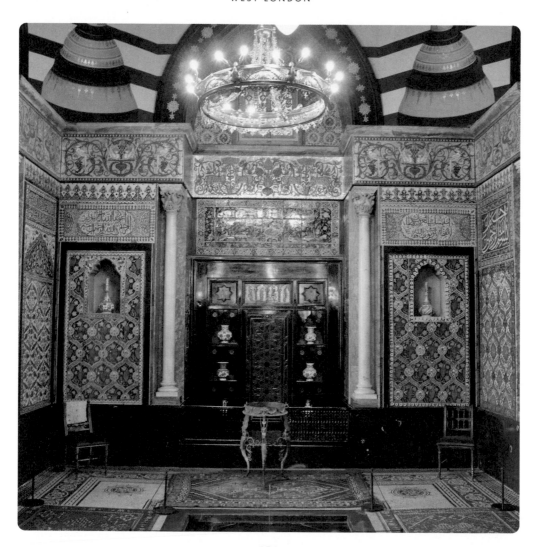

✤ LEIGHTON HOUSE MUSEUM

CULTURAL HISTORY

One of West London's most extraordinary museums, Leighton House is startling because, looking at the building's brick facade, you could be in mid-nineteenth-century England, but step inside and it's like being inside a Moroccan palace. Polished mahogany and shiny floor tiles reflect ceilings adorned with gold tiles and mosaic patterns. This 'private palace of art' pays homage to Arabic art – the Arab hall is decorated with Islamic tiles and a huge gold dome. Everything in the house was built to artist Lord Leighton's precise requirements over a period of thirty years. Queen Victoria even came to visit. The artist lived alone in this big house, sleeping in a bedroom on the house's first floor. It was rumoured that he fathered an illegitimate child with one of the female models who regularly sat for him, but aside from this piece of scurrilous gossip, his solitude only adds to the mystery of this strange house. The museum was undergoing restoration at the time of writing. Please check the website to plan your visit.

—

12 Holland Park Road, W14 8LZ
020 7602 3316
www.rbkc.gov.uk/subsites/museums/
leightonhousemuseum
See website for opening hours; £
High Street Kensington Tube

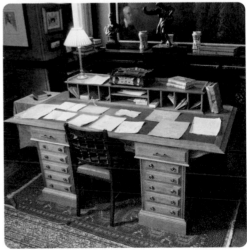

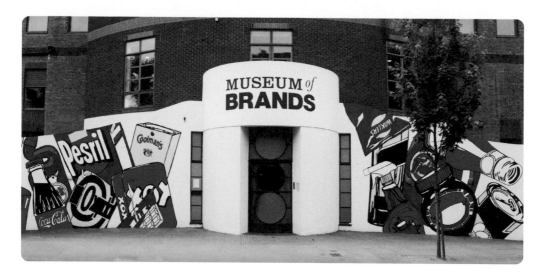

✤ MUSEUM OF BRANDS

<u>GRAPHIC DESIGN</u>

Branding dominates our lives. Few of us could see a specific shade of red and yellow and not know immediately what fast-food brand it represented, or hear the notes of a jingle and not immediately recognise the store. But how did brands evolve, and in what ways did they win our hearts and minds? The Museum of Brands, housed in a snazzy art deco building near Notting Hill, seeks to answer these big questions, while offering a trip down memory lane. The museum also considers how big businesses are preparing the packaging of the future – sustainable plastics for supermarkets,

for example – and there are interactive exhibitions and features to entertain visitors of all ages. The space also hosts talks by representatives from advertising firms, who explore questions such as how powerful brands can boost shareholder value. This is a quirky, relevant museum, and one that's well worth spending time in to explore just how much our lives have been influenced by the world's biggest names in the commercial sphere.

—

111–117 Lancaster Road, W11 1QT
020 7243 9611
www.museumofbrands.com
Daily 10:00–18:00, Sat.11:00–17:00; £
Latimer Road Tube

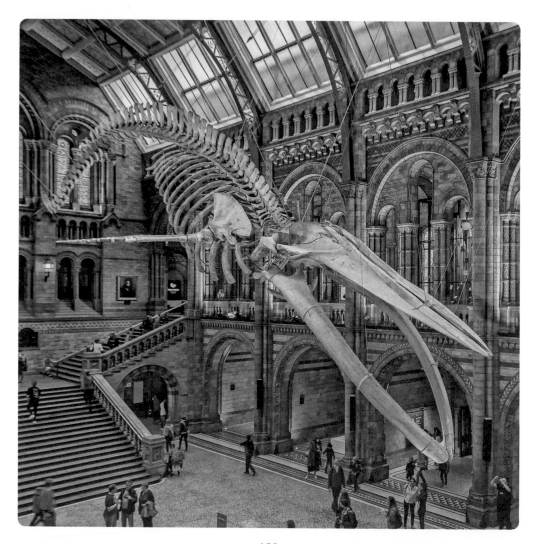

♣ NATURAL HISTORY MUSEUM

NATURAL HISTORY

The Natural History Museum's central hall glitters. In summer, sunlight streams across the vaulted ceiling, while in winter uplighters make it shimmer gold. Look closely, and you'll see the ceiling has 172 painted panels, each depicting a plant from across the world. The smooth arches in the central hall have a secret, too – see if you can spot the seventy-eight clambering stone monkeys studded into the pillars. It's a beautiful setting, made especially fabulous by the hall's ability to suspend enormous animal skeletons from the ceiling. The Natural History Museum is famous for its dinosaur skeletons and specimens collected by Charles Darwin. A statue of Darwin sits in the main hall, as he oversees the future he helped to build. The whole building is crammed with odd bits and pieces – there's even a 14,000-year-old drinking cup made from a human skull. Entry is free, as are many of the exhibitions. Children love this museum, and there are plenty of quizzes and child-friendly messages to intrigue them.

—

Cromwell Road, SW7 5BD
020 7942 6230
www.nhm.ac.uk
Daily 10:00–17:50; free
South Kensington Tube

✤ POLISH INSTITUTE AND SIKORSKI MUSEUM

MILITARY HISTORY

Poland was decimated during the Second World War – first by the invading National Socialists from Germany, and then by the Russians. As part of the Polish Institute opposite Hyde Park, this little museum preserves the memory of Polish military who fought alongside the Allies. Among the medals and military uniforms are the remains of a Polish plane shot down by the Luftwaffe, historical pieces stolen by the Germans from Poles and later found in caves, and even a saddle used by Napoleon Bonaparte. The building is ornate, with

the museum arranged on four floors. What really sets this place apart, however, are the museum guides. Poles who survived the war sometimes volunteer to work here, so visitors popping in to look for family names in the institute's archives may be treated to meeting someone who actually knew an uncle or grandfather. Note the opening times: the museum's hours are limited, so plan your trip in advance.

———

20 Princes Gate, SW7 1PT
020 7589 9249
www.pism.co.uk
Tues.–Fri. 14:00–16:00; free
High Street Kensington Tube

Stuart Middleton, 'Known Unknowns' exhibition, 2018

✤ SAATCHI GALLERY

CONTEMPORARY ART

With its shockingly white dystopian walls, this is the gallery to visit if you crave clean, contemporary creations. Opened by Charles Saatchi in 1985, to house his private collection, the gallery, despite its neoclassical home (the Duke of York's HQ), feels very bling. It supports the work of lesser-known international artists, while also playing host to superstar exhibitions, such as the last outing of Tutankhamun's treasure before it returned to Egypt. Back in the 1990s, Charles Saatchi sold most of his American art and decided to champion the work of the Young British Artists (YBAs). Admitting the work wasn't necessarily always brilliant, he wanted to promote 'the hopeful swagger of it all'. Outside of dedicated exhibitions, entry is free, and visitors can expect three floors of artworks that might include trippy videos, prints or riotous mobiles. Newer artists may be found milling around their exhibits, and are often happy to chat, so if you want to get abreast of what's happening in the art world, this is an excellent barometer.

—

Duke of York's HQ, SW3 4RY
www.saatchigallery.com
Mon.–Weds. 09:00–18:00, Thurs.–Sat. 09:00–22:00, Sun. 09:00–20:00; free
Sloane Square Tube

✤ SCIENCE MUSEUM

SCIENCE AND TECHNOLOGY

Packed with gadgets, gizmos and whirligigs, the Science Museum is a place of wonder in which visitors of all ages will get a thrill from what's on display. Check out the world's first-ever iron lung, designed to help polio sufferers breathe; the Apollo 10 command shuttle; rocket launchers; and futuristic technology, all housed across multiple museum floors. The gallery poses plenty of questions about the future of science, such as 'are driverless cars benign?' And speed freaks can climb into simulators and pretend they're in the Red Arrows. This is a great space for kids, as plenty of the exhibitions in this free museum are interactive: there are 3D and 4D simulators to try out, and in the Wonderlab gallery kids can watch scientists perform wild experiments. Lates run monthly and are for adults only. Expect silent discos, a bar, talks associated with the most recent exhibition, and workshops that include such things as 'what it feels like to fall into a black hole'.

—

Exhibition Rd, SW7 2DD
0333 241 4000
www.sciencemuseum.org.uk
Daily 10:00–18:00 (last Weds. of the month
18.45–22:00); free
South Kensington Tube

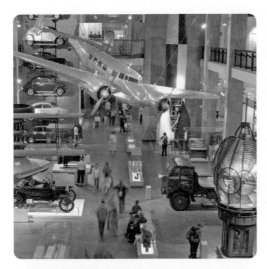

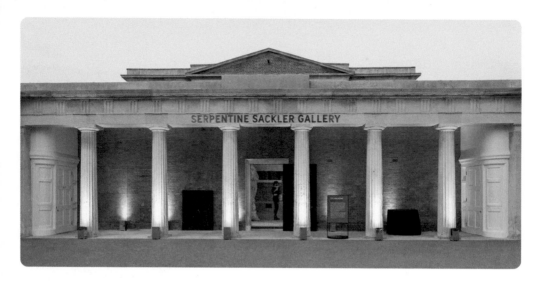

❧ SERPENTINE GALLERIES

MODERN/CONTEMPORARY ART

These two free galleries share one of the most enviable locations in London. Between them, they attract around 1.2 million visitors a year, and the location in the centre of Hyde Park surely contributes to this. The galleries are threaded together via a classical-style bridge that arches over the Serpentine Lake. They're only a few minutes apart and both focus on contemporary art and large-scale pieces. While some of the art is so new and cutting edge you might walk around wondering quite what it's trying to convey, other exhibitions showcase international names such as Henry Moore, Anish Kapoor and Jeff Koons. From June to October, visitors to Hyde Park's Kensington Gardens will also see a temporary pavilion, commissioned annually by the Serpentine. Leading architects Asif Kahn and Frank Gehry have contributed to this tradition, among others. If you're looking for a cool spot for an aperitif, try Chucs Cafe Serpentine in Zaha Hadid's stunning Magazine extension to the gallery.

—

Kensington Gardens, W2 3XA
020 7402 6075
www.serpentinegalleries.org
Tues.–Sun. 10:00–18:00; free
Lancaster Gate Tube

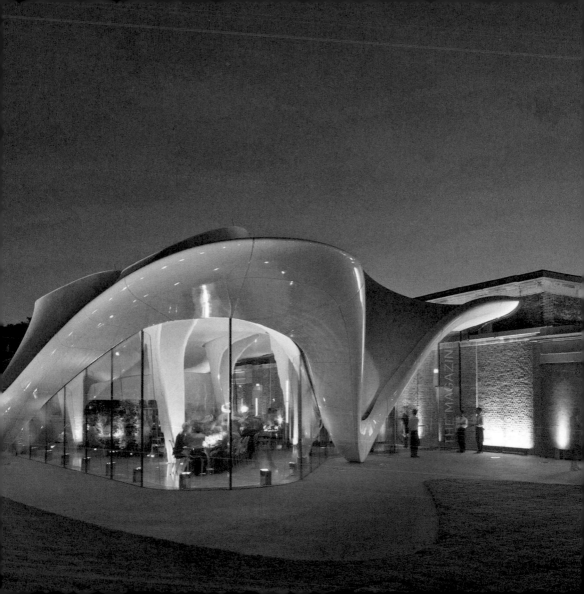

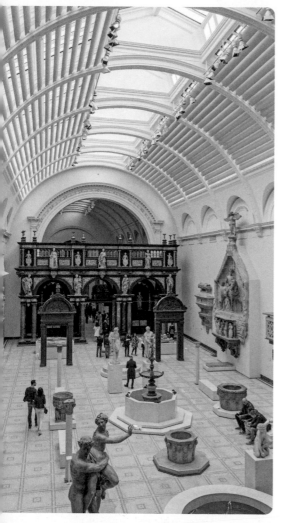

✤ VICTORIA AND ALBERT MUSEUM
CULTURAL HISTORY

In 1899, Queen Victoria laid the founding stone at the V&A during one of her final engagements before her death in 1901. The museum sprawls across 150 galleries, and is home to what may be the world's oldest floor covering, in the Islamic Art galleries. Other big hitters include the world's largest collection of Italian sculpture outside of Italy, and a marvellous collection of gowns – from eighteenth-century Jane Austen-style floor-skimmers to 1960s chiffon. Whether you're in a gallery of silver cutlery or striking medieval screens, the museum goes beyond eclectic. Each section is beautifully curated, and the changing exhibitions are unmissable if you can secure a ticket. One past show featured past and future computer games, while another celebrated the swinging sixties and culminated in a fabulous, almost lifesize replica of Woodstock Festival. Gallery space dubbed Rapid Response Collecting features contemporary works related to political events and global movements. Admission to the V&A is free, but expect fees for one-off exhibitions.

Cromwell Road, SW7 2RL
020 7942 2000
www.vam.ac.uk
Daily 10:00–17:45; free
South Kensington Tube

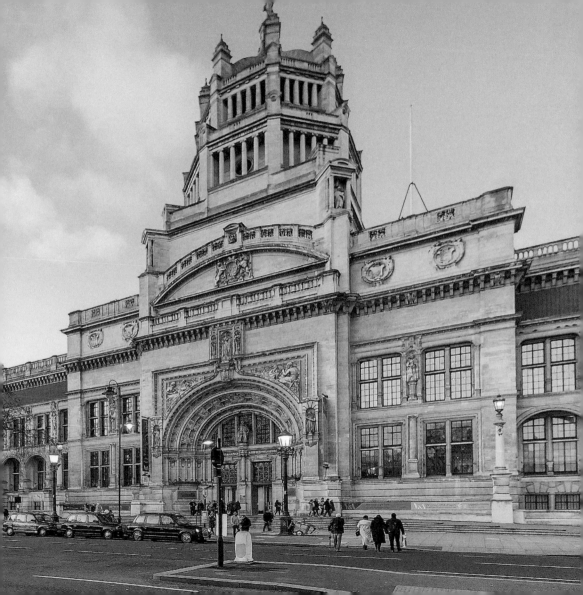

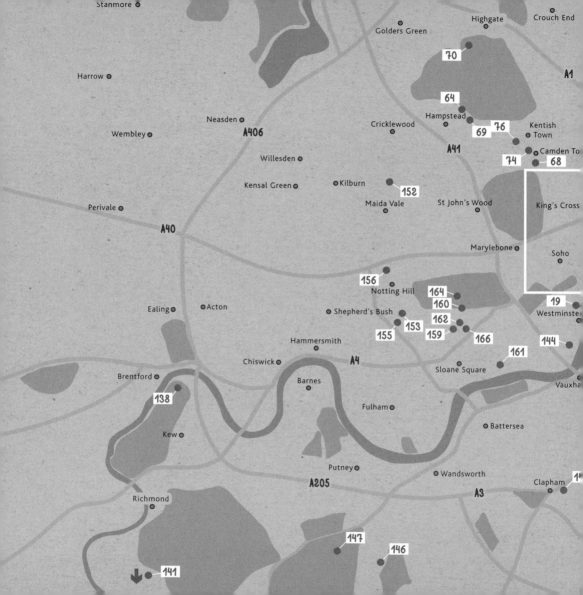

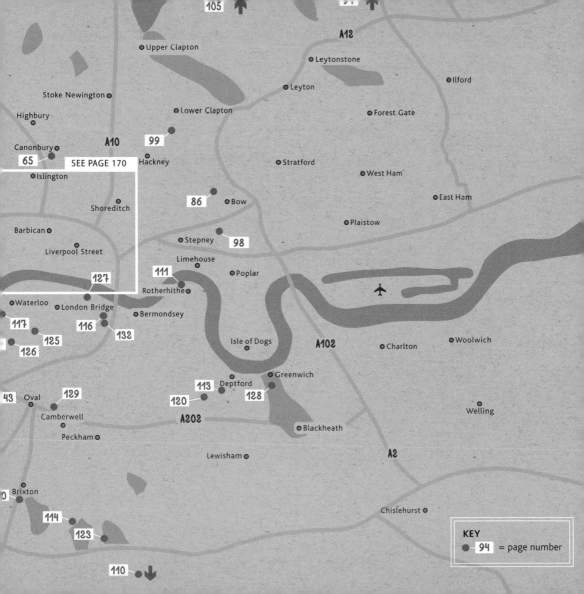

A12

Upper Clapton

Leytonstone

Ilford

Stoke Newington

Leyton

Forest Gate

Highbury

Lower Clapton

A10

99

Stratford

West Ham

Canonbury

65

SEE PAGE 170

Hackney

East Ham

Islington

Plaistow

Shoreditch

86

Bow

Barbican

Stepney

98

Liverpool Street

Limehouse

111

Poplar

127

Rotherhithe

Waterloo

London Bridge

Bermondsey

117

116

132

125

Isle of Dogs

A102

Charlton

Woolwich

126

Greenwich

43

Oval

129

113

Deptford

120

128

Camberwell

A202

Welling

Peckham

Blackheath

Lewisham

A2

Brixton

Chislehurst

114

123

110

KEY

94 = page number

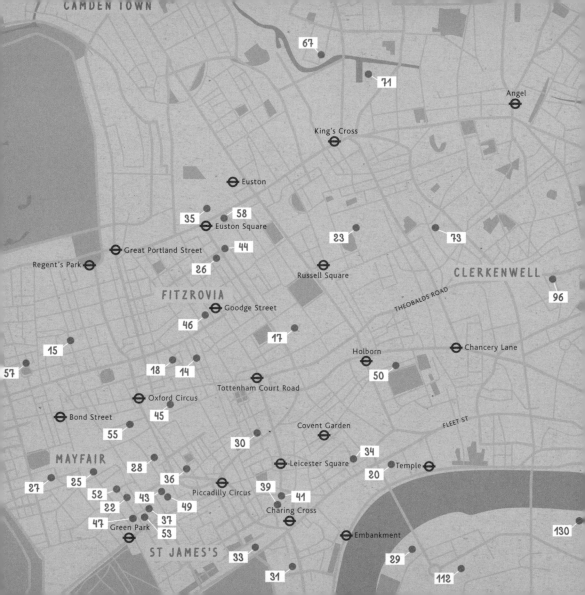

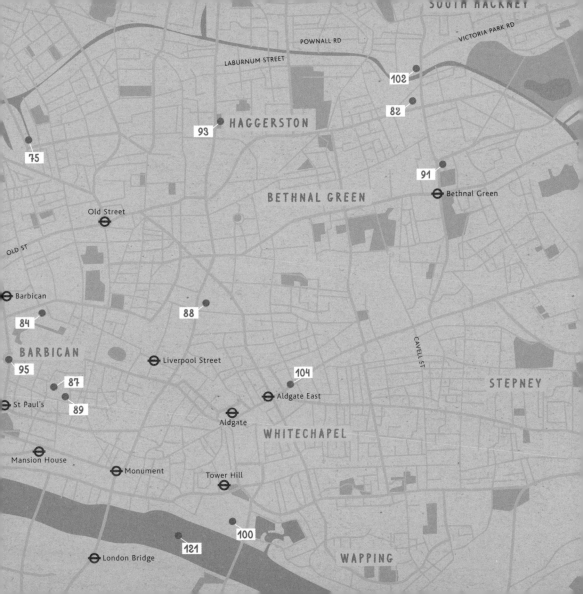

INDEX

Antiquity

Architecture/Design

Cultural History

Fine Art

Graphic Design

Health and Medicine

Picture credits

Andersphoto/Shutterstock.com: 17B, 38; Courtesy of Alison Jacques Gallery, London: 14; Arcaid Images / Alamy Stock Photo: 70; Joseph M. Arseneau: 100L; Bailey-Cooper Photography / Alamy Stock Photo: 48; Andrew Baker / ©AELTC: 146B; Roelof Bakker: 76, 88; Ben Uri Gallery and Museum: 152; Photo by Karen Bengall / Courtesy of Richard Saltoun Gallery: 47; Mark Blower: 33, 120B; © Matthew Booth 2009; Photo: Tim Bowditch / Courtesy the artist and Zabludowicz Collection: 62; 76-77; Eden Breitz / Alamy Stock Photo : 32; Courtesy of British Dental Museum: 15; Richie Chan / Shutterstock.com: 130; Courtesy of Chris Ridley: 92; Chrispictures/Shutterstock.com:46T; City of London Corporation / Keats House: 69; Courtesy of City of London: 87; Matt Clayton / Courtesy of UCL: 44; Courtesy of the artist and Studio Voltaire, London: 142; Dafinka / Shutterstock.com: 131; Ian Dagnall Commercial Collection / Alamy Stock Photo: 136; Photo: Alex Delfanne / Courtesy Hauser & Wirth: 22, 28; Deptford Does Art: 113; Claudio Divizia: 39B, 144B; Claudio Divizia/Shutterstcok.com: 16, 82; © Song Dong, courtesy Pace Gallery: 42R; Dulwich Picture Gallery: 114-115, 176; Adam Eastland / Alamy Stock Photo: 166; Nicolas Economou/Shutterstock.com: 17T; Kate Elliot / The Photographers Gallery: 45; elRoce/Shutterstock: 158; Charlie J Ercilla / Alamy Stock Photo: 29B; Courtesy of Estorick Collection: 65; © Fashion and Textile Museum: 116; The Florence Nightingale Museum: 117; © Murray Fredericks, Courtesy of Hamiltons Gallery, London: 27; Gareth Gardner / © Sir John Soane's Museum: 50, 51Tl, 51TR, 51BL; © GG Archard / The Foundling Museum: 23; Image courtesy of Goldsmiths CCA: 120T; Photo: Damian Griffiths / Annka Kultys Gallery: 82-83; © Paul Grover: 60, 66-67; Courtesy of Guildhall Art Gallery & London's Roman Amphitheatre: 89; Hemis / Alamy Stock Photo: 104; Horniman Museum and Gardens: 123b; Courtesy of Household Cavalry Museum: 31; Hufton+Crow-VIEW / Alamy Stock Photo: 96; I Wei Huang: 145; © Alex Israel / Photo: Lucy Dawkins / Courtesy Gagosian. 24-25; © IWM: 19, 121, 124TL, 124TR, 124BL, 125, 124BR; © Rob Pinney; Courtesy of Jayne Lloyd: 93T, 93B; Benedict Johnson Photography / Courtesy of Jewish Museum London: 68; Kamira / Shutterstock.com: 12; Justin Kase zsixz / Alamy Stock Photo: 41; Eman Kazemi / Alamy Stock Photo: 154, 155B; Photo Andy Keate / Chisendale Gallery: 78, 86; Photo: Voytek Ketz / Courtesy Sprüth Magers: 52; © Anselm Kiefer. Photo © Ollie Hammick / Courtesy White Cube: 133; Kiev.Victor: 144T; Kiev.Victor/Shutterstock.com: 83TR; Dan Kitwood / Getty Images: 110; Graham Lacdao: 118-119; Reproduced by permission of the Langdon Down Museum and Down's Syndrome Association UK: 141; Courtesy of London Transport Museum: 2, 34; Loop Images Ltd / Alamy Stock Photo: 90; Thomas Lovelock / ©AELTC: 146T; Peter Macdiarmid / Getty Images: 102; Raf Makda-VIEW / Alamy Stock Photo: 83TL; Courtesy of Marian Goodman: 36; Courtesy of Marlborough Fine Art: 37; Sam Mellish / Getty Images: 46B; John Michaels / Alamy Stock Photo: 91; Courtesy of MinaLima: 10, 30; Beata Moore / Alamy Stock Photo: 147; © James Morris / Courtesy Victoria Miro: 75; Museum of Brands: 156-157; © Museum of London: 7, 94-95; © National Maritime Museum, Greenwich, London: 108, 128; Trustees of the Natural History Museum, London: 1, 159; The National Trust Photolibrary / Alamy Stock Photo: 99; nobleIMAGES / Alamy Stock Photo: 97; Nathaniel Noir / Alamy Stock Photo:83BR; Old Operating Theatre Museum & Herb Garret: 127; © Adam Pendleton, courtesy Pace Gallery: 42L; © Justin Piperger, 2018; Courtesy of The Polish Institute and Sikorski Museum: 160; PriceM/Shutterstock.com: 100R; rabbit75_ist/iStock: 101; Courtesy of Ragged School Museum: 98; Eugene Regis/Shutterstock.com: 153; Royal Botanic Gardens, Kew: 138-139; Tom Ryley / © Sir John Soane's Museum: 51BR; Image courtesy of Saatchi Gallery, London: 150, 161; Maurice Savage / Alamy Stock Photo: 155T; Peter Scholey / Alamy Stock Photo : 49T; © Science Museum Group: 148, 162-163; Alex Segre / Alamy Stock Photo: 39T, 40; Sophia Spring / Horniman Museum and Gardens: 122, 123T; Spring / Horniman Museum and Gardens: 123b; Andy Stagg: 129; Jim Stephenson: 18; Morley von Sternberg: 29T; Studio MDF/Shutterstock.com: 167; Courtesy of The Cello Gallery: 112; © The Courtauld Institute of Art, London: 21TL, 21TR, BL; © The Courtauld Institute of Art, London/Benedict Johnson Photography ltd: 20, 21BR; Courtesy of The London Canal Museum: 71; The Magic Circle: 35; The National Trust Photolibrary / Alamy Stock Photo: 64, 99; © The Postal Museum: 72-73; Courtesy of The Serpentine Galleries: 164-165; The Sunday Painter: 143; © The Trustees of the Wallace Collection: 56-57; Courtesy of Tornabuoni Art / © DACS 2020: 53; Yuri Turkov / Alamy Stock Photo: 134; Simon Turner / Alamy Stock Photo: 111T; © James Turrell, courtesy Pace Gallery: 43; UCL, GMZ and Matt Clayton: 26; ukartpics / Alamy Stock Photo: 49B; Unit London: 54-55; UrbanImages / Alamy Stock Photo: 140; Vibrant Pictures / Alamy Stock Photo: 111B; VictorHuang/Getty images: 4; Steve Vidler / Alamy Stock Photo: 126; Courtesy of Wellcome collection: 58-59; Ben Westoby: 132; Wikipedia: 103; William Morris Gallery: 105; Wiskerke / Alamy Stock Photo: 83BL; Angus Young: 74;

Brimming with creative inspiration, how-to projects and useful information to enrich your everyday life, Quarto Knows is a favourite destination for those pursuing their interests and passions. Visit our site and dig deeper with our books into your area of interest: Quarto Creates, Quarto Cooks, Quarto Homes, Quarto Lives, Quarto Drives, Quarto Explores, Quarto Gifts, or Quarto Kids.

First published in 2020 by Frances Lincoln Publishing, an imprint of The Quarto Group.
The Old Brewery, 6 Blundell Street
London, N7 9BH,
United Kingdom
T (0)20 7700 6700
www.QuartoKnows.com

At the time of writing, organisations across London were adversely affected by the Covid-19 pandemic. Many venues closed for long periods of time and events were cancelled. Readers are advised to check the status of any venue, and its opening times, before visiting.

A catalogue record for this book is available from the British Library.

ISBN 978 0 7112 5752 8

Ebook ISBN 978 0 7112 5753 5

10 9 8 7 6 5 4 3 2 1

Editor: Anna Southgate
Designer: Dave Jones
Picture Researcher: Sarah Bell

Printed in China

MIX
Paper from responsible sources
FSC® C008047
www.fsc.org

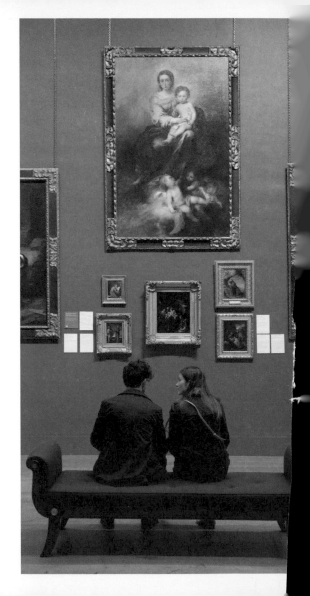